THRESHING DAYS

The Farm Paintings
of Lavern Kammerude

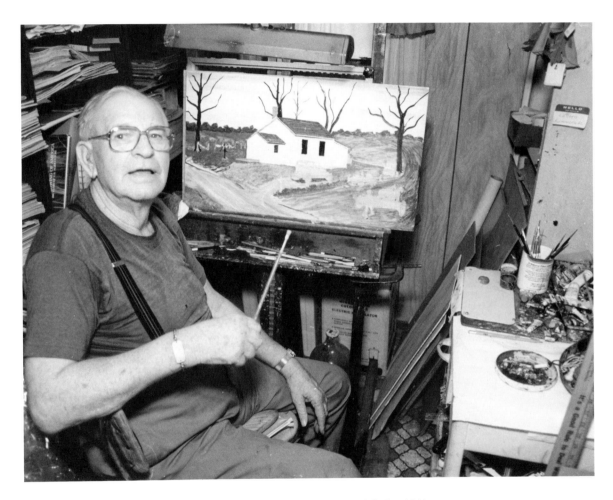

LAVERN KAMMERUDE (1915-1989)

THRESHING DAYS

The Farm Paintings
of Lavern Kammerude

TEXT BY CHESTER GARTHWAITE *From Chet*

Introduction by James P. Leary

WISCONSIN FOLK MUSEUM
Mount Horeb, Wisconsin
1990

ISBN: 0-9624369-1-7
Library of Congress Catalogue Card #90-71096
Manufactured in the United States of America
Printed on acid-free paper
10 9 8 7 6 5 4 3 2

Frontispiece: Lavern Kammerude in his backroom studio, painting *Sweet Clover School,* 1989. Photograph by Rich Rygh, *The Capital Times,* Madison, Wisconsin. Additional photographs in the introduction are courtesy Marcella Kammerude Klarer (pp. 10, 11, 12, 15), and Mildred Kammerude (pp. 13, 14, 16).

Book Design by Lewis Koch
Editing & Production Coordination by Philip Martin
Typesetting by KC Graphics, Inc., Madison, Wisconsin
Printing by Park Printing House, Verona, Wisconsin

The Wisconsin Folk Museum is a non-profit organization devoted to the documentation and preservation of the living folk arts and folkways of the state and Upper Midwest region. This is done through field research projects, museum exhibits, publications, technical services to artists and regional agencies, and sponsorship of live programs such as concerts and craft demonstrations. The museum's educational publications serve to bring the rich and diverse folk culture of the region to greater public attention.

For a catalogue of other folk art publications and folk music recordings, write: Wisconsin Folk Museum, Mount Horeb, Wisconsin 53572.

This book was made possible in part with grants from the following agencies:

Dane County Cultural Affairs Commission
Wisconsin Arts Board
National Endowment for the Arts/Folk Arts Program

with additional support from:

The Evjue Foundation
American Family Insurance Group
Wisconsin Power & Light Foundation
American Breeders Service
State Bank of Mount Horeb

CONTENTS

Preface . 8

Introduction
Lavern Kammerude, Farmer and Artist . 10

Spring Planting . 18

The Blacksmith Shop . 22

The Cheese Factory . 26

Haying Time . 30

Milking Time . 34

Belgian Power . 38

Threshing . 42

Dinner for the Threshing Crew . 46

Steam Power . 50

The County Fair . 54

Yellowstone Church . 58

Silo Filling . 62

Rural Free Delivery . 66

A Farm Auction . 70

The Country Store . 74

Corn Shredding . 78

A House Party . 82

Woodcutting Bee . 86

A Winter Day . 90

Maple Sugaring . 94

Sweet Clover School . 98

Epilogue .102

Appendix
Paintings and Collections .103

PREFACE

The idea for this book began in 1986. The Wisconsin Folk Museum, a new museum for the folk arts of the state, had just opened in the town of Mount Horeb. Richard March, traditional arts coordinator for the Wisconsin Arts Board, suggested that we consider displaying the paintings of an elder farmer living twenty-five miles south of Mount Horeb between Blanchardville and Argyle. That summer, the Folk Museum inaugurated its first season with an exhibit of ten of Lavern Kammerude's paintings.

The response to the small exhibit was overwhelming. From city slickers to area farmers, all were drawn into the colorful, detailed stories told by this ''plain painter's'' brush. In particular elder farmers with their white hair, seed caps, and sun-wrinkled faces would stand in front of each painting and reminisce about how they used to carry water to the threshers, or the names of favorite farm horses they rode as children, or their own trips to neighborhood cheese factories.

That summer, the Folk Museum also commissioned a painting from Lavern. As director, I had been active for years collecting stories from Wisconsin's old fiddlers, so I asked Lavern to do an old-time ''house party'' scene. In mid-1988, I got a telephone call. The painting was ready if I wanted to come down. About a half hour later, I was knocking on the frame of Lavern and Millie's back door. A sunny day, we sat outside on the porch and Lavern carried out a framed piece of painted masonite and set it in my lap. ''I hope it's okay,'' was about all he said. For me, it was an amazing window opened onto the past. That moment was the first time I was able to see one of the farmhouse dances from the 1920s that so many old fiddlers talked about.

I coaxed a few details out of him. ''Well . . . that guy taking off his coat [Lavern pointed with one of his huge farmer's fingers]—he can hardly wait to get his coat off, 'cause he's spotted those guys in the back room pouring the homemade wine.'' He indicated the fiddle player in the corner and admitted, ''I tried to make him look like you. And the accordion player is Rick March [at the state arts council, who does indeed play an accordion].'' In this piece of folk art, the museum directors and public folklorists actually had become part of the art they were studying!

Later in 1988 the Folk Museum asked Lavern if we had his permission to make a book on his paintings. He gave us his okay, although he seemed to wonder why we were making such a big deal over his work. In 1989, with grant support from the Wisconsin Arts Board and the Dane County Cultural Affairs Commission, we were able to start research and book preparation.

Tragically, in September, 1989, Lavern passed away from complications following a minor accident. Sitting in the balcony of a little Blanchardville church crowded with Lavern's family, friends, and neighbors, I felt even more that a book was needed to help this unique legacy of a farmer artist find its broadest audience.

With the support of Lavern's widow Millie, his grandson Edward Kammerude, and Eldon Hird, attorney for the Kammerude Estate, we were able to continue with our project after Lavern's death, bringing the book out one year later. We hope the family feels it is a fitting memorial.

Constant encouragement for the project came from long-time promoter of Lavern's paintings, Gerald Regan. Now retired after thirty-four years working for a dairy equipment company, Gerry Regan served since 1981 as Lavern's art agent, negotiating sales of originals and issuing a series of limited-edition art prints. In a close working relationship with the artist, Gerry commissioned from Lavern in the period 1977 to 1989 nearly all the scenes which appear in this book. This premier collection, on loan, also formed the Folk Museum's first exhibit in the summer of 1986. Gerry Regan deserves credit especially for having encouraged Lavern to document the seasons of work on a family farm, and for being one of the first to realize that such talent is a treasure to share with the folks of the Midwest and nation.

Many of the images in this book are available as full-sized, frameable art prints, some in limited, signed editions. For more information, contact Regan Sales, P.O. Box 117, Plato Center, Illinois 60170, or the Wisconsin Folk Museum.

Gerry Regan also introduced me to another farmer, Chester Garthwaite of nearby Fennimore. Chet had been Gerry Regan's high school agriculture teacher in Mineral Point in the late 1940s. Regan thought Garthwaite as retired farmer and teacher would be able to furnish the Folk Museum with information on the old practices depicted in Kammerude's paintings. Chet stopped in the museum one day, we talked a while, and I asked if he would try writing up a little background explanation on one of Lavern's paintings.

A few days later in the mail an envelope arrived, the first of a series of delightful short "histories." Reading it, I realized here was the missing element: the story of each painting. Reflecting on Lavern's images, Garthwaite's text reveals what is happening in each scene, and why.

Especially for us non-farmers, the stories are wonderful tools to draw readers into the rich detail of each painting. The narratives help to achieve a goal the Folk Museum had with this book: to present farmlife as more than a children's story of a farmer with some corn to plant and cows to milk. Rather, explains Garthwaite, traditional farming is an extremely complex occupation.

A farmer works with vast amounts of information gained, stored, and tested daily. Farmers are well-educated people, only their knowledge lies in things not learned from a book or classroom. As Chet Garthwaite told me in a classic farmer's understatement, "Let's just put it this way: You have to watch your calendar." For the old-time farms of the 1920s and 1930s, this meant managing dozens of varied and complicated operations.

Together, Kammerude's paintings and Garthwaite's stories present life on the southern Wisconsin family farm. The scenes roughly span the decades of the 1920s and 1930s. Some activities occurred a few years earlier or later, depending in part on the practice depicted and its varied use from one farm to the next. Traditional customs, which linger long after their introduction, are very hard to date. Chet has done a wonderful job to explain each scene, however, and is often able to offer a guess of a date or decade, often from the tiniest details which tell all to a farmer.

My personal gratitude goes to Chet Garthwaite for his willingness not to laugh too hard when, as editor needing to clarify small points, I had to pester him with so many questions revealing my far-reaching ignorance of cows, equipment, crops, practices—in fact, about most every aspect of farmlife that the youngest farm child takes for granted.

Many others did their part to help this book appear. Special thanks to Attorneys Mark Rooney, Andrew McConnell, Robert Horowitz, and James Harris for working out the legal details involving permissions to reproduce this work.

Along with funding assistance from the State of Wisconsin and Dane County, this project has also been supported in part by a grant from the National Endowment for the Arts which has allowed the Folk Museum to hire a research folklorist. Jim Leary's introductory essay presents Kammerude's personal and artistic background and links him to traditions of folk art based on farmlife memories.

Important additional funding was given to the Folk Museum to allow us to undertake this documentary project. Thanks in particular to Joanne Acomb of Wisconsin Power & Light, Fred Miller of the Evjue Foundation, Kurt Krahn of American Family Insurance, and Debra Boyke of American Breeders Service. Thanks to Don Bender of the State Bank of Mount Horeb for arranging the book's financing. Thanks also to the Mount Horeb Community Foundation and to the Elmer G. Biddick Charitable Foundation of Trelay Farms for funds to help purchase two original paintings by Kammerude (now on permanent display at the Folk Museum).

Finally, we dedicate this book to Lavern Kammerude's memory, and to his mother, Mary, a farmwife who believed in the talent of her son and always encouraged him to become an artist.

In turn, the book is dedicated to all the families of small farms in the Midwest. This rural heritage holds important values of family life and neighboring, of closeness to the land and the changing seasons. Passed from parents to children, farming as a traditional occupation is a resource as valuable as the land on which it takes place and the food which it produces. Whether we will learn to treasure that cultural heritage, which cannot be measured in acres or bushels, remains for future generations to decide.

Whether we live in a city of one million or one hundred . . . whether we know a Surge milker from a stripping pail, a Belgian horse from a Percheron, a heifer from a brood cow . . . we all depend in some way on this intangible heritage called "farming."

Philip Martin
Director
Wisconsin Folk Museum

INTRODUCTION

Lavern Kammerude, Farmer and Artist

"The farmer is the one who feeds us all."
—traditional song

Just as surely as midwestern farmers have produced milk, meat, eggs, vegetables, fruit, and grain for a hungry nation, they have made art that feeds the soul. Much of this art has been taken for granted by farmers themselves, has been integrated so tightly with everyday agrarian life as to seem invisible. Yet travel any rural road and consider what it would be without well-kept homes and outbuildings, without poetic farm names (Lone Pine Farm, Irish Acres, Windy Corners) and handpainted signs of Holstein cows on barn walls. Pause to take note of yards adorned with carefully arranged flower gardens, carved birdhouses, whirligigs, and planters or mailboxes cobbled from old implements. Enter any farm kitchen, parlor, or bedroom and consider how barren it would be without shelves of glimmering home-canned goods, embroidered towels, crocheted doilies, braided rugs, and the vivid geometry of patchwork quilts.

Such expressive pursuits, each concerned with the creation of some object essential to farm life, have been carried further by a rare few who have fashioned art that represents the whole of their rural existence. The rolling hills, high ridges, and deep valleys of southern and western Wisconsin have known a good share of those few, particularly writers like Hamlin Garland, Laura Ingalls Wilder, Carolyn Ryrie Brink, Ann Pellowski, and Ben Logan whose nationally celebrated stories and novels capture farm life from the mid-nineteenth century to the mid-twentieth. Their mostly fond portrayals avoid both romantic hokum and cartoon simplicity in favor of realism. Their farmers are neither noble toilers nor mud-caked bumpkins, but complex human beings—each more or less pious, profane, foolish, wise, grim, cheerful, generous, parsimonious, rugged, and frail—who work hard, confront the instabilities of the weather and the market, and try to get along. Although

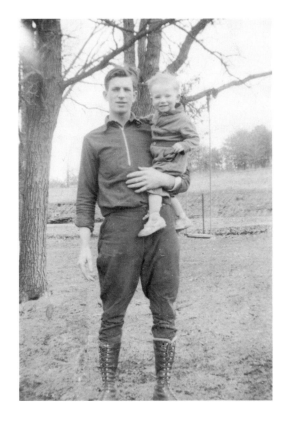

Lavern Kammerude as young father, late 1930s.

cast in another medium, and intended initially only for a local audience, Lavern Kammerude's paintings, the plain yet detailed work of an unassuming farmer, likewise speak the truth.

Lavern Kammerude, the oldest of Pete and Mary Kammerude's three children, was born on the family farm south of Blanchardville, Lafayette County, Wisconsin, in 1915. His father was Norwegian and Irish, while his mother, a Kainz, was Austrian. The rural neighborhood also included English and Swiss peoples. Most of them, like the Kammerudes, engaged in diver-

sified farming: cows, pigs, sheep, and chickens for food, wool, and a little cash; horses for power and transportation; hay, corn, and oats to feed the beasts.

Pete Kammerude was also a road maintenance patrolman on highway 78 that ran past the farm and so from the time Lavern was ten he, like many another farm boy, was milking, hauling milk with a team to the cheese factory, spreading manure, ploughing, planting, and harvesting. His schooling never went beyond eighth grade. By his early teens, Lavern Kammerude was doing a man's work on the home farm and cooperating with neighbors for seasonal tasks like threshing, silo-filling, and wood cutting.

In 1934 Lavern met Mildred McQuillan of nearby Argyle at a dance in Blanchardville. They married a year later and, since his parents' farm could not support a new family, Lavern worked for five years as a riveter with a steel construction crew based in Iowa. He built bridges throughout southwestern Wisconsin and in Iowa, and erected docks in the Mississippi at Prairie du Chien.

In 1939, when Lavern was twenty-four, his maternal grandfather, John Kainz, died, leaving his farm. Lavern and Millie settled in a tiny house next to his parents and began to work both the Kammerude farm and the Kainz place a mile and a half away: three hundred acres in all. Although he eventually purchased a small tractor, Lavern chiefly practiced the "plain old-fashioned farming" he grew up with, relying on draft horses and milking a score of Holsteins by hand for the milk check that, along with eggs sold in Argyle for "grocery money," was the main source of income.

Mildred recalls, "it was hard." Still the couple found time to enjoy dances and house parties, especially after they tore down an old house to build a larger place next door to their first farm home.

Neighbors got together and we just pushed the furniture back in one big room, and his uncle and cousins [the Gemplers] had a little orchestra. And they played and everybody danced and had a little wine. His dad [Pete] made wine. And the women brought food. Had a little food. Put the babies upstairs to bed. That was it. Everybody had a good time.

By the 1950s, however, Lavern had stopped running Pete and Mary Kammerude's farm. Like many a place in hilly southwestern Wisconsin, it took too much work to bring in too little money. In 1967 he turned the old

Kainz place over to a son who farmed briefly before moving to suburban Washington, D.C., with a Virginia-born wife he had met while in the military.

From 1967 through 1987 Lavern Kammerude worked for Argyle Industries in Argyle, eight miles to the south, rebuilding cylinders and other automotive parts. No longer farming, he remained on the home place where he kept race horses, raised their feed, and in summers hired a trainer and driver to enter his animals in sulky races at fairs in Green, Iowa, and Lafayette Counties. The horses never won much, but Lavern was "horse crazy" and, as he often joked to his wife, "we made enough for beer money."

Kammerude began to paint in earnest in the early 1960s, before he quit farming, when his mother presented him with a set of oil paints one Christmas. No doubt she remembered his childhood hobby. As Lavern subsequently told

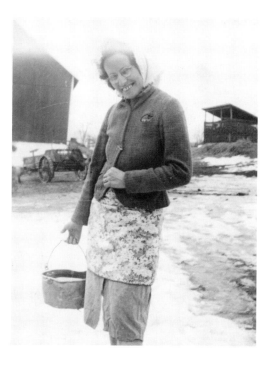

Lavern's mother, Mary, on the farm, 1940.

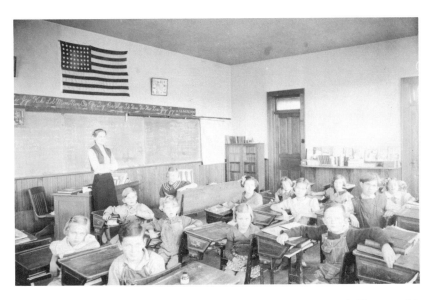

One-room Einerson School, which Lavern attended, just up the road from the Kammerude's farm. Photo ca. 1930.

one journalist, he had "always loved to draw horses. I started out when I was just a kid. I always drew pictures. We never had art in the one-room school I went to, but I did more drawing of horses than what I was *supposed* to be doing." Now in his fifties, Lavern started dabbling in painting. To encourage him, his mother also enrolled Lavern in the Famous Artist Correspondence School which critiqued his early efforts through the mail.

Evenings after work in Argyle found him setting up an easel in a backroom, meditating on a subject, blocking out and sketching sections of his painting-to-be on masonite purchased from the local lumberyard, then daubing color with tiny brushes grasped in his large rough worker's hands. He showed his first paintings to Hank Anderson, proprietor of Hank's Tavern in Argyle, a place where Kammerude and fellow workers stopped for a quitting-time beer. Anderson bought seven or eight and hung them on the wall. Other locals did the same and Kammerude was soon exhibiting in a Blanchardville art show.

His most enthusiastic customers were farmers and businesses serving a rural clientele. In 1970 Farm Credit Services bought paintings to hang in their offices, as did Surge, a leading dairy equipment supplier. While many customers might request simply a portrait of their homeplace, perhaps supplying a photograph, others were more captivated by Lavern's talent for recalling a bygone way of life. In 1977, Gerald Regan, a Surge executive and a former farmboy from nearby Mineral Point, was taken with Lavern's scenes of corn harvests and cheese factories. Regan's interest in old farming practices led him to commission scenes over the next dozen years that applied Kammerude's penchant for detail to a broad range of seasonal rural activities.

Eventually acting as Kammerude's agent, Regan began bringing the retired farmer's work, through the sale of prints and originals, to the attention of regional and national galleries, buyers, dairy farming and country living publications, and cultural institutions. Soon a Kammerude painting graced the walls of the United State's Secretary of Agriculture and, in 1986, with the help of the Wisconsin Arts Board's Folk Arts Program, Lavern Kammerude was awarded a "Governor's Heritage Award" by chief executive Anthony Earl for his renderings of old-time rural life.

In 1987 Kammerude retired at seventy-two after twenty years at Argyle Industries. He could finally paint as much as he wanted. Mildred Kammerude remembers:

> I always told him artists are moody, and when the mood took him he'd paint. Sometimes he'd get up early in the morning and he'd start painting in the morning—I would have to call him to lunch. Then other times he would sit all afternoon and not do a thing . . . Everything was thought out before . . . Everything was in his head . . . And then [he would] just get up and walk out [to his backroom studio] and paint until he got tired at night.

Similarly, Gerald Regan recalls:

> Lavern was a genius. He had all that detail stored up here [in his head]. And he'd sit there, almost in a trance in front of one of his paintings—with a paintbrush in one hand and a cigarette in the other—and just stare at it for a long time as if he was in a different world. Which he was.

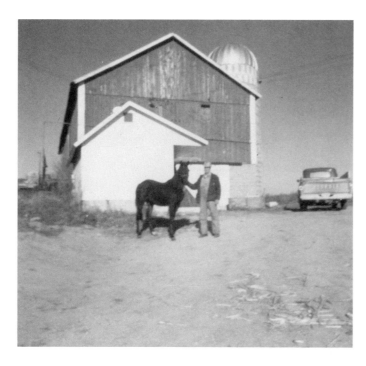

Lavern with horse, 1965.

Lavern Kammerude died in September, 1989, of blood poisoning complications following a yard accident. At his funeral in a packed Blanchardville church a sheaf of grain was displayed along with an unfinished painting, dual symbols of the life of a farmer and artist.

Lavern Kammerude painted what he knew and never thought his work was anything special. He was happy if others enjoyed what he did, but all the attention, the "hoopla," that came his way was disconcerting. When he received his 1986 Heritage Award in the gilded Governor's reception room with its fine art decor and murals, all he said in accepting was that it seemed "like a lot of fuss to make over an old guy like me." But those who admired his paintings knew how special they were.

The paintings concern rural life in southwestern Wisconsin from Kammerude's boyhood in the late 1910s through roughly the mid-1940s. During most of that period the family farms of this hilly region of the state were small, diversified, reliant on horse power, and dependant upon local markets. For the exchange of labor and the enjoyment of sociability, farm families were also aligned in informal neighborhoods. When Lavern was farming, the Kammerudes did their "neighboring" with the Corbins, the Daleys, the Bergs, the Kainzes, and the Jacobsons. Their kids went to the country school up one hill and hauled milk to the cheese factory up another. Neighbors enjoyed a beer together at the tavern, polkaed and waltzed to old-time music in home and hall. The country church that grandfather Ole Kammerude helped found was a short ride away. For those families, farming was more a way of life than simply a way to make a living—more agriculture than agribusiness.

Nowadays farming is more specialized. Automated machines have replaced horses, markets are global, and neighborhoods are no longer intact. Country schools have been abandoned to consolidation, country cheese factories have been shut down by economics and regulations. House parties and family taverns have diminished in competition with entertainment media. Some country churches hold on, sharing ministers with nearby congregations, while the rest have been converted to other uses, or simply abandoned.

Lavern Kammerude experienced all these changes, like most farmers, without resistance. Yet he knew that farming would never again be what it was when he was a boy and a young man. He missed working with horses so much that he kept some around to race. And he especially missed the experience of working, consulting, and visiting with the folks across the fence or down the road whose families were farming too. "There was a lot more togetherness then . . . As the years went on you didn't even know your next door neighbor."

Through his paintings, Kammerude expressed appreciation of his lost world by concentrating on the seasonal occasions when neighbors gathered to work, play, trade, worship, and work some more. His portrayal of the intricacies of communal labor and of the equipment used to carry it out was extraordinarily precise. Through painting, he could recollect and relive the past: "I've done it and I can see myself there." Mildred Kammerude noted

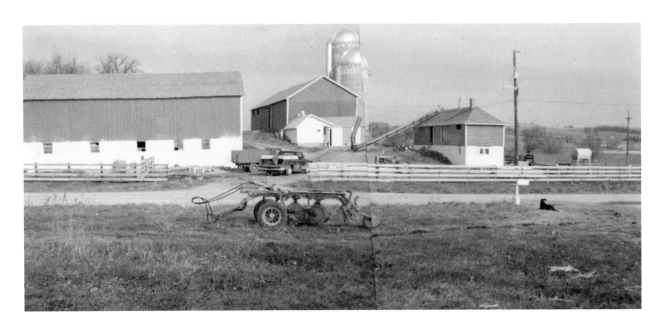

The Kammerude farm, south of Blanchardville, Wisconsin, late 1960s.

that many others who saw his work felt the same. Transported to a time and space only alive in memory, ''They'd say, 'I used to do that,' or 'This looks like my uncle's or my grandpa's place.' ''

The paintings, in fact, were composites, bits of several places in the region, familiar combinations of landscape, chores, equipment, animals, and architecture. He often packed more into a single scene—a panoramic view of threshing or of silo-filling—than any eye might have commanded. And sometimes he condensed isolated moments—at a county fair or a house party—into a unified image. Kammerude worked from memory, but it was an artistic memory that sifted and shaped. He surely recalled but did not paint the accidents, tragedies, and carelessness that bedeviled many a farmer. No storms soaked hay or lodged oats, no teams ran away, no equipment broke down, no thresher gears snagged cloth and flesh, no downed cattle bloated

in fields, no worn-out equipment lay junked in gullies. Doubtless Lavern reckoned farmers would rather dignify their walls with glimpses of a job well done, the satisfaction of honest sweat triumphant. Like a cinematographer fond of late afternoon light, Kammerude offered us his vision, a ''golden age'' of southwestern Wisconsin farm life.

While Lavern Kammerude's paintings emerged from his own life and vision, he was not without artistic influences. The bookshelf of his backroom studio held Norman Rockwell's vignettes of small town America and editions by Frederick Remington and Charlie Russell, illustrators of America's nineteenth-century west. Less ''cute'' than Rockwell, less ''stiff'' than Remington, Russell was Lavern's favorite. Russell painted the working cowboy, Kammerude painted the working farmer. Both favored precise detail, action, and broad vistas. Both Russell and Kammerude had a feel for the

seasonal rhythms and tactile nuances of outdoor work. Both had a sense of humor and a preference for small scenes within the larger composition. Kammerude's trademark throughout many paintings was the young boy, patterned after himself or a son, carrying water to the men or driving a team, often followed by a dog.

With his obvious influences from the fine art world, gained through books and correspondence school training, Kammerude does not conform to strict notions of a folk painter. He did not learn in a traditional manner from others in the community who worked in a style passed down through the generations. Nor did he—like area farmer and outdoor muralist Frank Engebretson whose local work Lavern admired—paint bucolic scenes on barn walls. Rather Lavern is what folklorists term a "plain painter." Although his painting is not strictly traditional, his use of personal memory to tell "stories" of rural life shares much with the traditions of other folk artists, especially craftsmen and raconteurs.

Throughout the midwest many men of Lavern's generation have valued their rural past. In retirement, some have turned their industrial skills with wood and metal to crafting miniatures of the machines, tools, and beasts they remembered: threshers, steam tractors, cultivators, and combines; sleighs, hay wagons, harnesses, and horses. Their handiwork fills shelves and tables in their homes, it travels with them to farm toy shows and display barns at old-time thresherees. No mute things, their objects are, like Kammerude's paintings, icons of bygone rural society. Each compresses a way of life into a tiny artifact. Each is a "conversation piece" that might inspire hours of reminiscent talk between maker and viewers.

Reminiscent talk often runs to artful story. The rural world's many opportunities for narrative exchange—as farmers gathered at the cheese factory, the feed mill, the livestock auction, the country tavern, the blacksmith shop, the church dinner—produced raconteurs who chronicled the truth and fictions of farm life. More listener than talker, Lavern told his stories with a paintbrush. For instance, he often painted virtually the same scene, with minor substitutions, at the request of customers. Like the best verbal performer he varied the narrative gems in his repertoire to please an audience.

The Kammerude paintings in this publication carry us through a farmer's year from spring planting through snowfall and back to springtime. Those who have farmed will bring their own experiences to what they see. But those who have not may need a guide, like Chester Garthwaite, to enter fully the territory of agrarian memory.

Chester Garthwaite, author of the companion text to the paintings included here, was born in 1919 on a farm in Mount Hope Township, near Fennimore, Grant County, southwestern Wisconsin. After a farm boyhood, he entered college and became a high school agriculture teacher, first at Granton, Clark County. After serving in Europe in World War II, he came back to teach again, this time in Mineral Point, Iowa County. In 1948 he returned to the home farm in Mount Hope to become a full-time farmer. He farmed until 1979, when he became an Adult Farm Trainer with the vocational school in Fennimore, serving the districts of Belmont, Darlington, Schullsburg, and Mineral Point. He is now mostly retired and lives in Fennimore, although he still occasionally puts in a ten-hour day on a tractor, helping his son David on the Garthwaite family farm.

His dual role as farmer and teacher has made him particularly adept at grasping and conveying a sense of bygone farm life in southwestern Wisconsin. While Kammerude's paintings illustrate that life, Garthwaite supplies informed commentary based directly on these paintings. His narratives blend

Lavern with race horse, possibly at Lafayette County fairgrounds, 1960s.

Lavern and Mildred Kammerude, 1988.

fact and anecdote. They draw on personal memory and on resources ranging from the comments of his wife, Eugenia, and other senior farm couples of the Fennimore area to his father's handwritten farm journals dug out of a closet. The interplay of Kammerude's images and Garthwaite's commentary replicates the discussions that happened for hours on both occasions when the two men met in the summer of 1989. It is the kind of collaboration that emerges naturally whenever agrarian iconographer meets rural raconteur.

Lavern Kammerude and Chester Garthwaite invite you to look and to listen.

James P. Leary
Staff Folklorist
Wisconsin Folk Museum

Sources

Titles by the western Wisconsin writers mentioned include: Hamlin Garland, *A Son of the Middle Border* and *Main Traveled Roads;* Laura Ingalls Wilder, *Little House in the Big Woods;* Carolyn Ryrie Brink, *Caddie Woodlawn;* Ann Pellowski, *First Farm in the Valley;* and Ben Logan, *The Land Remembers.* Mildred Kammerude offered memories of her husband during a tape-recorded interview I conducted with her on May 7, 1990; the tape and an index are part of the collection of the Wisconsin Folk Museum. Quotes from Lavern Kammerude himself have been culled from feature articles in many publications, including: the *Argyle Agenda* (October 8, 1981); *Country* 3:3 (June/ July 1989); the *Land O Lakes Mirror* (December, 1981); and the *Monroe Evening Times* (November 27, 1987). Additional information on Kammerude was provided by Marcella Kammerude Klarer, Richard March, Philip Martin, Gerald Regan, and Hank Schwartz. Finally, more about commentator Chester A. Garthwaite can be found in his autobiography, *They Are In My Genes* (Eau Claire: Heins Publications, 1989).

The Paintings
of Lavern Kammerude

**with text
by Chester Garthwaite**

Spring Planting

The farmer's year began in springtime. In the month of May, an age-old ritual was repeated as the first seeds were put into the ground. From this point on, an annual cycle was set in motion. There would follow days, weeks, and months of work, of worry, of satisfaction as crops grew and livestock prospered. The farmer would watch the weather, guard against sickness in animals, fight weeds in his fields and pests in his grain. He would repair machinery, keep horses healthy, and hope for the farmer's dream: "a good year."

This painting shows an interesting method of corn planting that will revive many memories among elderly farmers, though the techniques shown may be mysterious to the younger farmers of today.

The "planter wire" in the foreground demonstrates a way that farmers controlled weeds prior to chemical or herbicide methods. In those days, cultivation up and down the rows destroyed only the weeds between the rows. By using a planter wire with its regular knots, it was possible to cross-cultivate the corn to eliminate weeds growing within the rows.

The planter wire was normally 80 rods or a quarter mile long, although some farmers would sometimes splice an additional length on for a longer field. The wires had "knots" or splices every 42 inches. To begin the planting process, the wire would be "staked" at one end of the field and the roll of wire, mounted on the rear of the two-row planter, would be unrolled the full length of the field.

The picture shows the farmer setting the stake wire at the exact center of the rear of the planter. The wire will then be locked into a "fork trip" on the side of the planter. As the team moves ahead, the knot in the wire will momentarily catch in the fork, trip a device in the planter, and allow three kernels to drop into the soil in both rows. The fork then slips loose from the knot and a spring repositions it instantly. Wheel-driven plates inside the seed boxes assured the correct number of seeds for each "trip."

Each time the wire was moved to a new row, the farmer would try to give a steady, uniform pull on the wire to straighten it and align the knots with those of the previous row. The goal was to be able to create a checker-board effect so that the corn could be cultivated either up and down or across the rows. It was essential that the stakes at one end of the field were set in an absolutely straight line, otherwise the cross-rows would not be straight. The stakes had two handles and a foot rest to help the farmer set the metal rod.

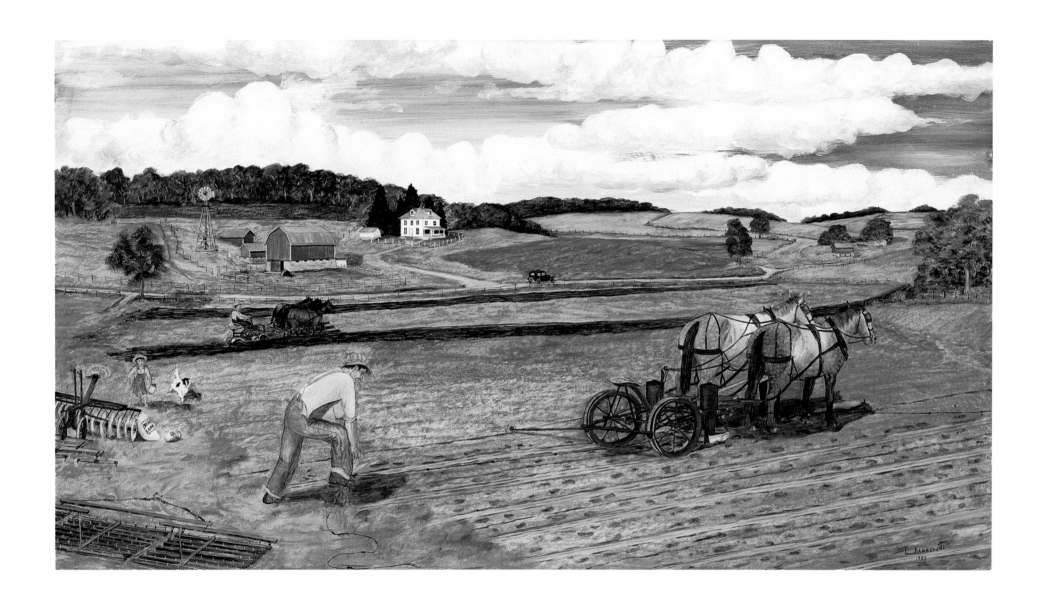

The farmer was always very selective regarding the team he used for planting. They had to travel at a uniform speed, about three to three-and-a-half miles per hour. The team also had to be very sensitive to the bridle bit, to keep the center of the planter directly over the "marker disc" line. You can see from the rows already planted the carefully aligned prints of the horses' hooves on each side of a center line. As each row is planted, the marker disc (which sticks out to the side of the planter) scores a line for the next row to come.

At the end of each row, the wire was released, and the team was turned around and positioned on the next row. The wire was tightened and reset, then the marker disc was flipped over to the other side of the planter as every other row was planted traveling in an opposite direction. In those days a planting rate of 12,000 to 14,000 seeds per acre was common, about one half of today's normal rate.

For seed, in those days of "open pollinated" corn, the farmer would pick out the best ears of corn in the fall as he unloaded corn, or he might "field select" before picking. Those ears were each placed on a spiked corn dryer so that no ears touched each other. Many times they stayed in the farm attic all winter. Then the tips and butts were shelled off by hand, and the ears fed through a hand-crank sheller until enough seed was produced for next year's planting. You will note a seed corn sack is leaning nearby, ready for refilling the planter boxes. This must have been a year that the farmer decided to change varieties and purchased seed from a seed company.

Note the little son, accompanied by the family dog, bringing the jug of water to the guys in the field.

In this scene, the plowing is not quite done in this field. In fact, with three horses hitched to a "sulky" plow, there is more than a day's work remaining. After the far field is plowed, the disc and then the harrow, now parked at the edge of the field, will be used to prepare the freshly plowed land for planting. It was considered good management to keep the planting operation caught up closely to the plowing. If a rain came, unplanted land would have to be reworked. If it stayed dry the planted kernels could take advantage of the moisture in the freshly turned soil.

In southern Wisconsin, corn planting seldom started before May 10 with all effort exerted to be done before June 1. As silos became more common, the farmer would often plant five to seven acres of a late, tall variety of corn for silo filling. Corn intended for silage was usually not planted with the check-row wire. Instead, a method known as "drilled" or "hill-drop" was used for a higher plant population. It could not be cross-cultivated, but weed control was reasonably good by turning the front shovels of the cultivator to "hill-up" the rows and smother weeds. Late-planted corn had less weed competition and the weeds that appeared were cut and used for silage so they did not reseed.

The method of corn planting depicted here became less popular in the early 1930s because of soil conservation programs. When cultivation was done up and down the hills, a severe rain could wash the soil to the bottom of the hills through the cross channels. Dads usually instructed their sons doing cross-cultivating to cultivate several widely spaced

rows lengthwise before quitting time, to develop a number of small dams. This was only effective for rather mild storms.

As more rolling land was enrolled in soil conservation measures, (such as strip cropping or contour farming), the narrow, curving strips made cross-cultivation impossible. Lengthwise cultivation with assistance of chemical weed control became very common by the late 1940s.

Older farmers will be able to determine that this painting depicts a planting operation just prior to the 1930s, for two reasons. First, there are no fertilizer boxes on the planter. Commercial fertilizer (with relatively low analysis of nitrogen, phosphorus and potassium, 3-9-3 or 4-16-4), became very popular in the 1930s to replenish nutrients lost through erosion. Farm manure could no longer take care of all crop fertilizer needs.

Second, look closely at the "tugs" on the harness (the pulling lines running from the harness back to the equipment). Chain-end tugs, having metal links at the ends to allow rapid adjustment of the harness to fit different-sized equipment or horses, were not yet in use. Instead, the adjustment on this harness was done from the front.

The final step in the planting operation was to harrow the field with the harrow teeth at a gentle slant to give uniform coverage of seed. A severe rain, followed by hot weather, sometimes caused a "crust" to form and another harrowing job would be necessary to allow the tiny plants to emerge.

The Blacksmith Shop

This springtime painting of a little crossroads community with a blacksmith shop, livery stable, and saloon recalls facets of village life in the 1920s. A modest settlement like this served not only the needs of its inhabitants but also those of surrounding farms.

The scene focuses especially on the blacksmith shop. In those days, light breeds of horses provided transportation for farm folk coming to town and for townspeople like doctors, clergy, and postmen who went out into the rural areas. On the farms, draft horses provided power to run machinery and field equipment. Accordingly, the village blacksmith shop was always a busy place.

The local blacksmith was trained as a farrier, one who shoes horses. Many a young blacksmith worked first as an apprentice for several years before being allowed to establish an independent business. At least in this part of the country, it seems that many of the skilled blacksmiths were of German origin. Incidentally, the term "farrier" means "foot-doctor" and is recognized by the veterinary profession. The theory "when the foot is gone, the horse is gone" made horse shoeing an exacting science.

When a team was brought in to be shod, they were tied, with heads held high, to rings attached to the wall. Harnesses were seldom removed. The blacksmith would select shoes of approximately the correct size, which he had made in his own forge. After the hooves had been rasped to an absolutely smooth surface, the rough shoes would be heated in the coal forge until they were a glowing yellow. The forge was heated rapidly by using a "bellows" that was operated either by hand or foot to force oxygen under the coal, causing the fire to burn fiercely. Then the shoes would be hammered on the anvil, mounted on a huge block of wood, to the exact shape of each hoof.

Normally a horse shoe had four nail holes on each side. Each hole had an indentation the size of the nail head, made while the steel was heated. This allowed the nails to be set in flush and prevented heads wearing off with constant road contact.

While shoeing, the blacksmith always wore a heavy leather apron or leggings over his normal trousers. A nervous or ill-tempered horse might jerk a foot through the legs of the blacksmith as he straddled the animal's leg. If the nails had not yet been clinched it would cause a serious wound without the leather leggings. When a horse was being shod for the first time or was bad-tempered, the owner frequently was assigned to place a "twitch" on the horse's nose to

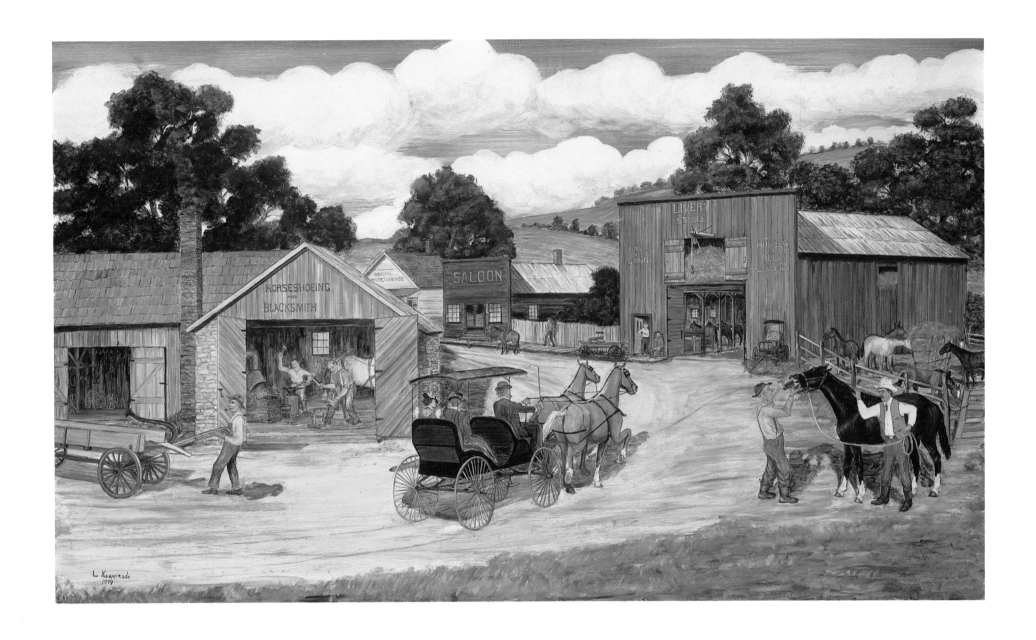

control it. Simply, the twitch was a small loop of rope attached to a short wooden handle. The rope was slipped over the horse's upper lip and twisted. If the horse became violent a sharp twist would cause such sudden pain that the horse soon forgot it was standing on only three legs. Most horses soon became tolerant and quiet after a few sessions.

The season of the year determined the selection of shoe type. In winter a "sharp shoe" was used to prevent slipping on icy roads and streets. At the time of the painting, this was done by bending the rear end of the shoe outward to a right angle and hammering this to a wedge which was sharpened. Likewise, the toe of the shoe had a sharpened bar of the same length welded on. Somewhat later, a "never-slip" shoe was developed that had removable cylindrical caulks threaded into the shoe. These could be removed and replaced.

In summer a flat shoe was used to protect the hoof from wearing down. Normally the outer surface of the hoof grows about .2 inches per month, but on an abrasive roadway it will wear away more rapidly and the tender "frog" of the foot will be exposed causing the horse to become "tender footed."

Some horses had to have special shoes made to cover the frog or protect insides of the hoof. The farmer usually knew of any particular gait problems of his team that made a special design necessary.

As the picture illustrates, there were many other tasks the local blacksmith was required to perform. The farmer loading his walking plow onto his wagon has returned to pick up his most essential implement after getting a new point welded to the plow "lay" and having it sharpened. Depending on the type of soil on his farm, he may have to return to have this operation done a couple of times this spring.

In those days, the blacksmith and his forge performed vehicle repair services similar to those now provided by a town's local gas station. On the horse-drawn wagons and buggies, the wooden wheels had steel rims which would become loose after years of travel. The riveted rims would be removed, heated, then plunged in water to cool rapidly, contracting enough to be refitted on the wooden wheel and reattached. This job required far more skill than rotating the tires on your car.

In early summer, the smithy will be flooded with mower and binder sickles for repair and replacement. Parts of other farm machinery that break must be brought in for welding, since no farmers had electric or gas welders at that time.

In the lower right corner of the painting a local farmer is inspecting a horse that a dealer has for sale. Perhaps the fact the dealer is so well dressed is causing the farmer some concern, for he is checking the horse's teeth. The age of a horse, up to nine years old, can be very accurately determined by checking the front teeth.

The livery stable played an important role in village life. Note the building with purchased hay stored in the loft, idle horses in the yard, plus a number of horses in individual stalls. Separate stalls were necessary as strange horses

might otherwise kick and injure each other. Not only did the stable manager own a number of teams for rental, but he would provide stalls for teams that were brought in after a long trip for feed, water, and rest.

It was common practice for the village doctor to own his own team and buggy, but have them cared for at the livery stable. If he had a call to a patient in the country the stable manager would quickly get the doctor's team hitched and ready for a fast trip. If the doctor had another call when he returned, a fresh team could be hitched and he was off again.

Even after the advent of the automobile, rural mail carriers often had to return to saddle horses or teams and cutter sleighs to make their routes when snow or mud prevented use of the early cars on country roads.

Stallion owners would sometimes keep several quality breeders at a livery stable, but would travel out to a farm to perform the breeding service, since the stallions needed exercise and the mares were not to be overheated after breeding.

The fee for team rentals varied, but fifteen cents per hour was typical. For the family who needed to travel only on occasion it was far cheaper than boarding and cleaning their own team.

On a pleasant working day the local saloon is obviously not over-crowded. Only one saddle horse is tied at the hitching post. That situation will be reversed tonight after the kerosene lamps are lit.

Note the stylishly dressed ladies, seated in the rear seat of the "surrey with the fringe on top." It was a status symbol to be delivered to a destination in a fashionable vehicle with a well-dressed driver and matched team.

Sanitation was important for both the livery stable and blacksmith shop. The manure from both places was loaded and delivered to a neighboring farm to prevent odors from lingering in the village.

The Cheese Factory

This scene presents a small building important to Wisconsin farming history: the country cheese factory. Even in the early decades of the 1900s most Wisconsin rural factories were producing excellent cheese. The native skills of cheesemakers, many of them of immigrant Swiss descent, were aided by continual improvements in technology, turning Wisconsin into a state famous for its cheese.

This painting is set perhaps in June, traditionally the heaviest milk-producing month. In the summer, each dairy farmer was responsible for delivering his own milk to the factory, usually by 9:00 or 9:30 a.m. daily. That gave the cheesemaker and his wife enough time to complete the tasks needed to make that day's batch of cheese, then clean the factory and equipment for the next day.

For hauling milk, typically a farmer would use a light farm team rather than heavy draft horses. The team would be hitched to a small wagon called a "milk buggy," and the cans loaded, ready for the brisk trot to the factory. Frequently several teams would be waiting in line at the cheese factory to unload. This gave the waiting farmers a chance to chat about local news, crop progress, and perhaps tell a few good stories.

In late winter and early spring, the light hauling team was exchanged for a heavier one. All farmers had to get their draft horses "hardened in" for spring work. Also, while the regular team was shod year-round, the draft animals were not, so a few miles travel without shoes was a good way to get their feet worn down after a winter of idleness.

Each spring, nearly every farmer had at least one colt to break. Hauling to the cheese factory was a good job to train them with, for the load was light, they could travel fast, and it acquainted the colt with unfamiliar territory. The colt was considered "broke" if, when the steam valve was triggered and a blast of steam and noise released, you still kept control. Usually the colt wore both a halter and bridle, with the halter rope tied to the well-trained, dependable horse used for breaking.

As indicated in the painting, two types of milk cans were used. The 30-gallon can had handles on the sides which could be hooked to a cable lift at the factory intake. After the farmer had inserted the hooks in the can handles, the cheesemaker would crank up the can to the desired height. The milk was then poured into the tank to be weighed on the scales. Also, a sample was taken for butterfat testing. These two factors—weight and butterfat content—determined

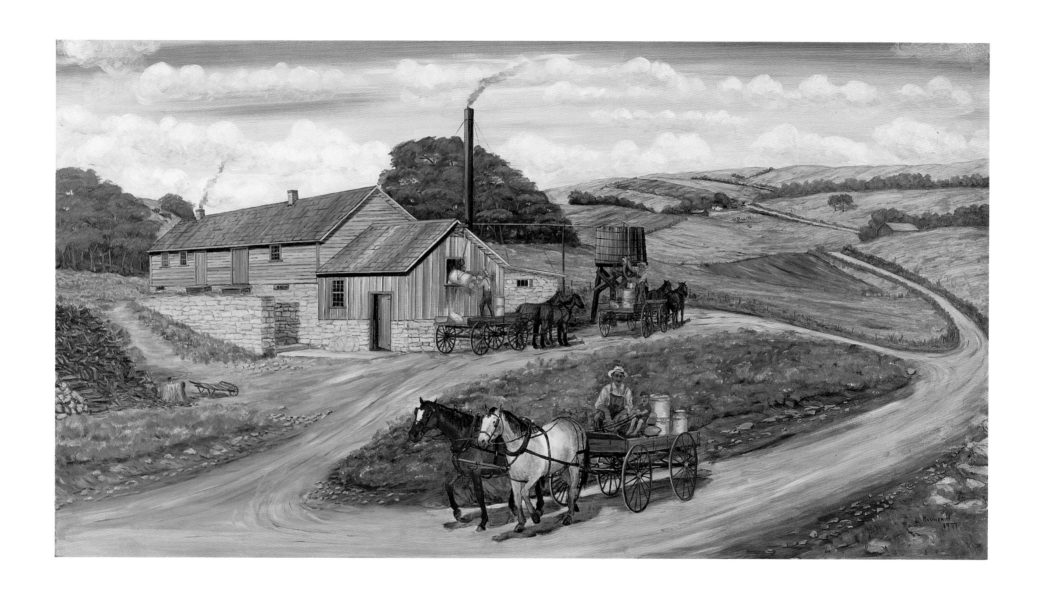

the size of the milk check the farmer received every two weeks. Very early, a type of filter disc was developed to insert in the tank·outlet to determine if any "sediment" was escaping the farmer's strainer at the farm.

Only a few years later, the 30-gallon cans were replaced almost entirely with 10-gallon milk cans and 5-gallon cream cans. Farm wives washed the milk cans and it was about impossible for them to scrub the bottoms of the large 30-gallon containers. Often on Saturdays or during summer months, farm boys who could handle a team well, but were not yet able to lift 100 lb. cans, would haul milk to the factory. Either the cheesemaker or an adult farmer would lift the cans to the weighing tank.

As illustrated in the picture, little kids frequently rode along to the factory, a chance for Dad to show them how to drive a team.

When the milk had been unloaded the farmer then drove to the whey tank where he filled his empty cans with whey to return home as hog feed. Whey is a very digestible form of animal protein and some farmers even brought extra cans if the plant had excess. Waste problems for the factory were virtually eliminated.

When winter arrived and milk spoilage was not such a problem, most factories operated only every second day. Furthermore, many rural factories closed down shortly after Christmas when most cows were dry, as farmers bred most of their cows to start "freshening" or producing milk again around March 1. During that two-month midwinter period, farmers generally had only one or two cows milking. This provided enough for the house milk, cream for churning or perhaps for a six-quart freezer of ice cream.

The cheesemaker and his family normally lived in the upstairs of the building, with the cheese manufacturing at ground level. The excess heat from the boilers provided some heat for the upstairs. During the slack period after Christmas, the cheesemaker might borrow an idle team from one of his patrons and spend some time cutting cordwood to supply fuel for his plant. For many, however, coal was the preferred fuel. The entire family was usually involved in school and community activities with their farming neighbors. Especially in southern Wisconsin, many of these cheesemakers were of Swiss origin, with yodeling and accordion-playing included in their favorite pastimes.

Eventually, teams and wagons were replaced with touring cars converted to milk-hauling vehicles. Still, in the winter, if roads became snowbound, farmers went back to horse-drawn sleighs, with two or three neighbors taking turns hauling the milk from several farms. During gas rationing of World War II, rural cheese factories started providing pick-up service for farmers and returning whey, as this was more efficient than each farmer delivering his own milk. Eventually, farmers switched to year-round milk production. In fact, winter would become a high production period.

The location of each local cheese plant was determined by several factors. First, it had to be within driving distance of a number of farmers who were engaged in dairying. This could include farms up to five or six miles away, although most were within a few miles. Second, it was essential that a good water supply was available. This meant that some plants utilized a spring, which could be sheltered from contamination and the water piped to the plant by gravity. Others used a well, but a windmill could not always be used for pumping because if the wind did not blow, the plant was without water. Before the days of gasoline motors, a treadmill was sometimes used to supply the power for pumping with a goat or pony supplying the energy.

Haying Time

The "hay-fork horse" in the foreground of this picture will be a reminder to thousands of former farm kids. Every one of these will remember the name of the quiet horse they rode or led to lift the hay to their barn hay loft. For my sister and me, it was Old Vic.

Haying was a family job. The season started somewhat later, in late June or early July, than it does now. Most hay crops then were a mixture of red clover and timothy, which matured somewhat later than today's alfalfa (and was coarser and of lower quality). Therefore farmers only got two "crops" or cuttings of the hay. Most farmers set aside some rather clean timothy as horse hay, for according to folk belief, clover was a little dangerous for horses' lungs, even if they did like it.

It was quite common to mow hay on the morning of the Fourth of July, then go to the local celebration at noon. From that time on, making hay was the main priority until oat-cutting time.

There were two types of barns for hay storage. The one featured here had a trap door on one end, large enough to accommodate a huge forkload of hay. With this style of barn, the team and wagon were stationed outside while unloading. A steel track ran the full length of the barn and each part of the hay mow could be filled in turn, depending on when the fork was tripped. The other type of barn featured an upstairs driveway. With this type the team and wagon were driven right into the barn for unloading.

Each type had its advantages. For the first type, a hot team cooled off faster when left standing outside in the breeze, and the center of the upper part of the barn could be used for storage. For the second, in the event of a rain coming up quickly it was possible to drive into the barn and protect the hay from damage.

Leading the hay-fork horse was the big money maker for farm kids. A common price was five cents per wagonload, with eight trips leading the horse to the chicken house and back normally serving to unload a full wagon. If some year the crop was so excellent that over 100 loads were harvested, a kid might earn a dime per load over 100.

When the youngster rode the horse, as illustrated here, a new hame strap would be installed on the harness. A broken strap could pull the harness off the straining horse and sweep the youngster off to the ground. When leading the horse, youngsters usually were instructed to pick up the idle rope midway on the return trip and bring it back near the bottom pulley. Over 150 feet of heavy rope lying on the ground caused so much friction that it was difficult to pull the fork back on its carrier.

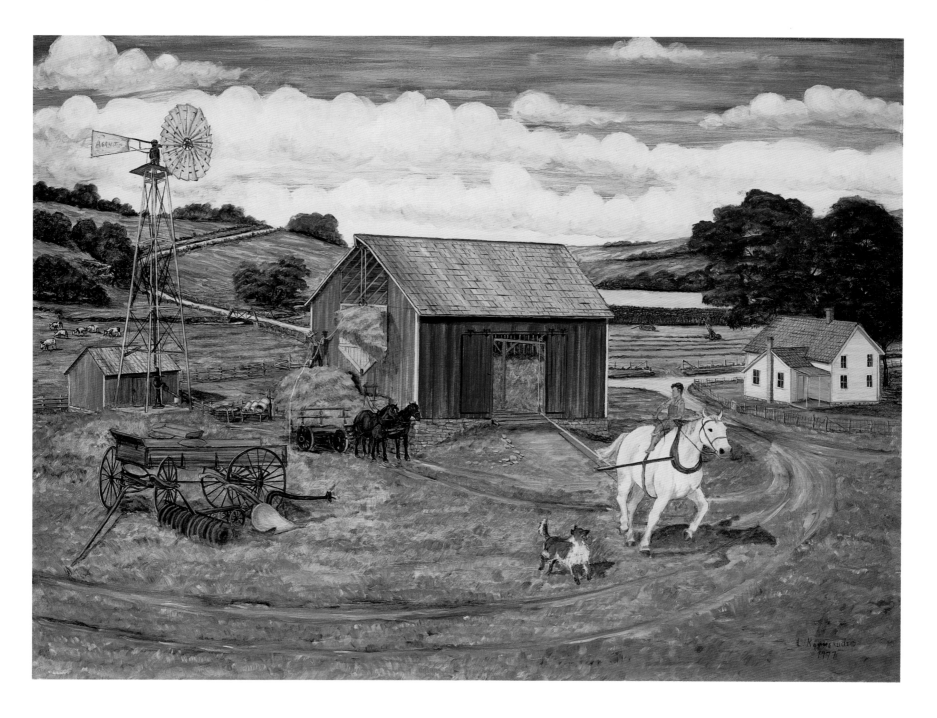

During hot summer weather many farmers would use the brood mare with the most recent foal to pull the hay-fork rope. The little colt could follow the mother on those few short trips or race around the barnyard, rather than stay in a fly-infested stall. The main precaution was to be certain the tiny colt was not entangled in the hay rope when the pull began, for it could be seriously injured. A semi-circular hay rope "single-tree" was common to keep the rope high on the mare's hips.

The most strenuous job was "mowing" the hay evenly in the loft, after it was dropped by the big fork. If it was not properly distributed it was very difficult to pry loose after it had settled several months. The next fork-full was not sent to the hay mow until the man with the pitchfork signaled that he was ready.

Frequently the kid leading the horse had a much worse job after each load was emptied. He would tie his horse in the shade next to the barn. Many old barns have the ring still stapled to the barn siding, used for securing the horse between loads. At this point the kid would climb on the wagon with Dad and return to the field to load up another wagon of hay.

In the field, Dad would back up the wagon to attach the old wood-slat loader to the rear end of the wagon. The youngster would drive the team, making sure that the horses walked slowly and straddled the windrow. The teeth of the loader, following behind the wagon, picked up the row of loose hay and lifted it to a combination of chain, wood slats, and light rope. This mechanism elevated the hay and dropped it in the rear of the wagon.

At first driving the team was an easy job, but as the rear end was filled a few feet, Dad started pitching hay to the front. Then the youngster had to start climbing the "standard" on front of the hay rack, to keep from being covered up with the rising hay. As the load became heavier the team often tried to increase their pace, so the youngster not only had to steer, but pull back on the lines to maintain a reasonable speed.

You will note the idle hay loader and rake in the field behind the house. The raking had been done early in the morning while the hay was still tough, to prevent leaves shattering.

Many times farm wives helped with hay mowing or raking in the morning. Seldom more than one load would be completed in the morning, but the afternoon was often very strenuous.

It was of extreme importance that loose hay was well dried before going into the mow. All hay would "heat" somewhat, but if it was green or not yet dry, "spontaneous combustion" could occur. In fact, some damp seasons, several barns in a community exploded and burned. Bales of hay were much less subject to combustion than loose hay, but bales would mold if the moisture was not reduced to at least twenty percent. There has been tremendous improvement in ventilation and drying equipment in recent years.

After several years those long, expensive hay ropes were certain to break under great strain. Many farmers did not know how to do a long splice, essential on a rope that had to go through a pulley. Persons who had mastered the art of splicing were on call over a large area to make those repairs rapidly.

In contrast to neighborhood operations like threshing, shredding, and silo filling, haying was typically a single family project. The risk of cutting large amounts of hay at one time and having it ruined by rain, plus the limited capacity of the haying equipment, made a slower operation more reasonable.

Let's remember, haying and threshing operations provided the fuel for all farming operations. The hay and oats that went into horses and mules were the equivalent of today's gas and diesel fuel for tractors.

Milking Time

This is a glimpse of a brief segment of agricultural history that spanned only a few years in the late 1920s and early 1930s. Yes, it is true that dairymen have been using milking machines for many decades, but look carefully at this painting. There are no electric wires going to this barn or milk house! How many of you knew that some farmers had milking machines before they had electric power?

Most people realize that at one time all cows were milked by hand. For that, the old-fashioned milk stools and buckets were the crucial elements of dairy equipment. By 1937, the Rural Electrification Act was in effect and most farms had electricity for milking. Just a few years earlier, however, the Great Depression from 1929 through 1935 had caused tremendous stress on farmers. During that period most farmers, even if they had electricity, had returned to hand milking to save money. In this picture, we probably are looking at a scene slightly earlier still, perhaps somewhere in the years 1925 to 1929.

During this short period, several companies such as De Laval and Surge had successfully marketed milking machines that were powered by stationery gasoline motors. These had been developed about 1907 but took some years to gain acceptance.

The gas motors not only provided power for the vacuum pumps and pulsators, as do today's electric motors, but they were also fitted with a large water tank that served two functions. First, the water surrounded the cylinder and cooled the motor. As an added benefit, in this process heat was transferred to the water. By the time milking was completed, an adequate supply of hot water could be removed from the tank to wash and sanitize the milking equipment. Naturally, it was necessary to replenish the water supply before the next milking. A gallon of gas would milk a twenty-cow herd about three times.

The milker units being carried by the farmer are manufactured by the Surge company. To milk, the buckets were suspended from an adjustable belt over the cow's back, just in front of the hips. This became a very popular machine and many modernized units are still in use.

The entire family will shortly be involved in the evening milking chore. The boy is pushing the can cart toward the concrete ramp at the end of the barn. The husband is carrying the two milking units, the maximum the vacuum line could handle. The wife is carrying the house milk can in one arm and the "stripper-bucket" in the other. After the

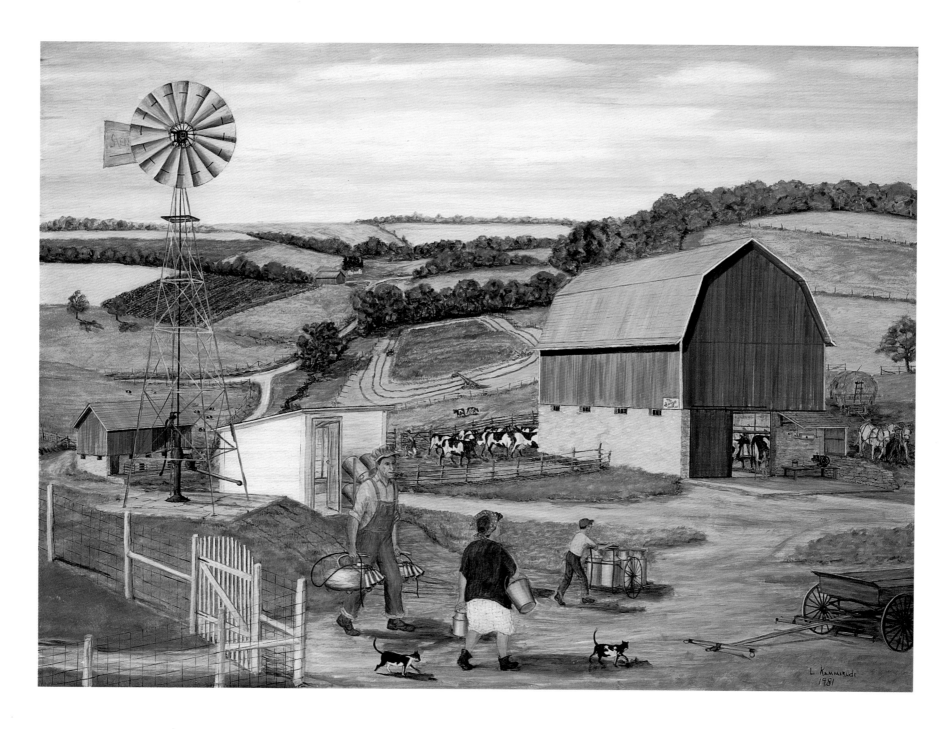

milking unit was removed from each cow, she will "strip" by hand the last of the milk from the cow's teats. These final "strippings" were highest in butterfat, and she will likely use this pail of rich cream to churn the house's own butter.

The hired man has unhitched the team from the last load of hay for the day and, after the horses are unharnessed, watered, and fed, he will join in the milking operation. Incidentally, a couple of farm cats also realize that it is time to get to the barn and take up their vigil near the cat pan, for some milk will be splashed in it shortly. If they are not there on time, that darned dog will come in and finish it off.

In a barn of this size it is doubtful if more than twenty cows will be milked. With two units the actual milking will be done in just under an hour. That is only part of the evening chores. The grain feeding of cows, the evening meal for baby calves, scraping the barn platforms, and sweeping mangers all had to be done. The young boy, who had no problem taking the empty cans to the barn, will have to allow Dad to return with the full cans.

The filled milk cans go into a cooling tank in the "tank-house." There, a water-pipe from the windmill enters the building. The overflow water goes out into the stock tank so as the cows drink, fresh, cool water will surround the milk cans.

The milking equipment will be washed up and hung upside down in the "tank-house" and while Dad and son take the cows to night pasture, Mom will hurry in to get supper on the table. The hired man will feed a few buckets of grain and whey slop to the Hampshire sows down behind the corn crib.

When Dad gets washed up and the family is seated at the table, the father will offer a little mealtime prayer, which will probably include, "Please don't let it rain on the two loads of hay that were raked, but not loaded tonight."

The old family cat will lick the last of the milk from the cat pan, climb to the corner in the hay mow where her kittens, with eyes not yet open, will nurse and settle down for the night.

The family will get to bed early, for this job has to be started again at 5:00 a.m. It is late July, and the pressure is on. Since the oats in the background are nearly ready for harvest, the haying must be finished as rapidly as possible.

Belgian Power

Lavern Kammerude had an evident fondness for horses. In this depiction of the oat harvest of late July, a magnificent three-horse hitch of Belgians commands center stage.

The Belgian breed is believed to have descended from draft horses used and praised by Julius Caesar. Actually the type of Belgian horse now popular in the United States is a vast improvement over the breed we knew just fifty years ago. The early stallions sired colts that were low set, heavy boned, with a decided crest to the neck, but not very active. They gradually increased in height to sixteen or seventeen "hands" (a hand is a measurement of four inches). They also became a more uniform color, and acquired a longer stride. They have always been good-natured horses that could handle long hours of heavy labor.

Older farmers will notice the details of harnesses found throughout these paintings. The low breeching, back-pad harness shown here was a type favored for heavy horses. This one also displays a high steel hame with an ornate ball at the top. This was popular not only because it was decorative but also because it was easily adjusted to collar size.

To pull the binder, if three horses of uneven strength were to be used, it was common to place the two largest, strongest horses on each side of the binder's tongue, with the weaker third horse used on the outside. A mechanism called "three-horse eveners" caused all three to pull an equal amount, but the two inside horses also carried the weight of the tongue, which could cause sore necks and certainly added to their work.

The old-style Deering binder shown here had a stiff tongue which balanced the entire binder and it required a strong man to lift the tongue and hitch the team. Years later a set of "truck" wheels would be added at the base of the tongue to reduce the neck load on the horses.

This style of binder was too wide to go through a normal gate, as it had a six-foot blade extending out from the side to cut the oats (this is hidden behind the horses in the painting). Therefore, moving from one field to the next was a major engineering task. Removable steel wheels were inserted into slots on the frame and the huge drive wheel was cranked up to clear the ground. The stiff tongue was then removed at the base and moved to be reattached under the side of the binder. Usually that required two sturdy men. The binder could then be moved sideways through the gate into the next field and the entire procedure reversed. Sometimes it was easier to take down a section of the fence!

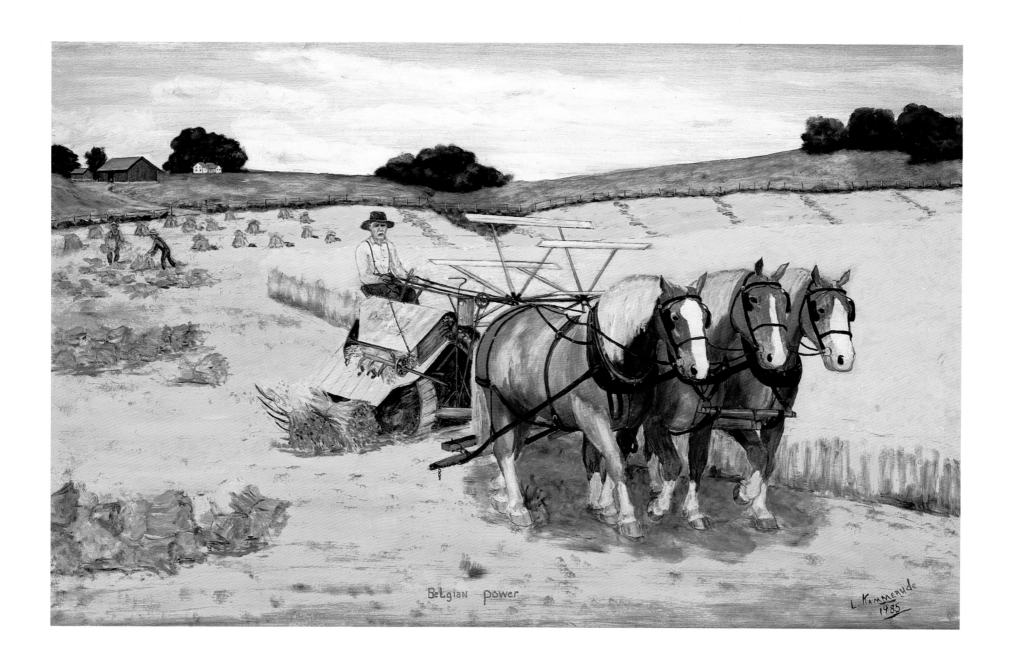

Belgian power

L. Kammerude
1985

The close-up view of the binder shows the bundle carrier as it fills from the knotter area, with the bundles ready to be dropped in the next shock row. You will note that the man on the binder appears near retirement age, while younger men are doing the shocking. Years of experience in adjusting binder knotters and keeping the equipment lubricated and in good repair probably earned the older gentleman the job with a seat!

Harvesting could not begin in the morning until the dew was evaporated from the grain. Damp hulls could start to mold or mildew and spread through the entire shock, which would seriously damage the quality of the grain. Veterinarians frequently attributed "heaves," a lung disease in horses, to moldy grain.

At noon, three fresh horses might be brought to the field to replace the tiring team and a substitute driver would take over while the other went to dinner. Later in the afternoon the regular team would be returned and often worked until dew became an evening problem. This lengthy day was possible only if there were enough kids to help the wife with the evening milking and other farm chores.

Although this picture does not portray it, oat harvest was usually a time of severe fly and bug problems. Many times farmers would use "fly-nets" on the teams, since the horses' tails could not scare away all the pesky flies. The nets were made of loose cords, stabilized by small fabric bands which allowed the strings to shift and frighten flies away, yet allowed the team to stay cool. Obviously this was in the days before fly sprays or bug repellents.

In the rear you will notice the two younger men doing the shocking. A good worker could shock from eight to ten acres per day. The shocks were often designed in a different manner depending on when threshing would begin—that is on whether the farm was scheduled first or last in the threshing run rotation. If the threshing was to begin soon, a six- or seven-bundle shock was used to speed drying.

However, if it would be several weeks before the threshers reached a farm, the "nine-bundle shock" was used. This involved placing three pairs of bundles in a row, then one on each side as a brace, then a ninth bundle as a "cap." This last bundle rested on top of the other eight and was spread out to cover the heads of the upstanding bundles. These shocks would stand lots of bad weather with only the cap bundle deteriorating.

In the event of rainy weather which soaked the shocks, it was often necessary to tear the shocks apart to dry a few hours before the threshing began. Usually that was done by farmers with forks, but most older farmers have seen two farmers each take a team, tie a rope between their bundle wagons, and drive together down opposite sides of a row of shocks. Yes, the rope would tip shocks over, but the time wasted recovering scattered bundles made that practice unpopular.

Returning to the horses, it is important to point out that a truly magnificent team, such as this, was a status

symbol of a successful farmer. Frequently by this time in the season work-horses' ribs were showing and there would be definite signs of exhaustion. This scene shows a proud farmer with enough horses to share the burdens of a long, hard season.

Threshing

Threshing is the harvest-time task prominent in the minds of most elder farmers. Technically, threshing (or "thrashing," as it is commonly pronounced) refers to the process of separating the kernels of grain, like wheat, oats, or barley, from the stalk. Threshing machines also removed ("fanned" or "winnowed") the useless chaff from the seed. For farmers of the early 1900s, however, "threshing" signified more. It was a peak period of neighborhood activity which occurred at the end of each summer, in late July or early August.

The threshing run started when all neighborhood farmers had finished, or nearly finished, cutting their grain and stacking shocks. Each year the order of farms was reversed, so that a family at the end of the run one year would be at the beginning the next. Accompanied by men from each farm with teams of horses, the threshing rig traveled from farm to farm. Its arrival on a farm heralded the culmination of the grain harvest. The seed planted in the spring, now multiplied, was gathered from the fields and stored away for the winter.

Although the basic task was the same from one community to the next, there were variations in practice and custom. One main difference centered around the ownership of the threshing machine. In some areas a custom operator would own a rig, which would be rented out to a group of farmers, the operator charging enough per bushel to make a profit.

The second option was for a group of local farmers to buy their own threshing machine, elect a "separator tender" and a treasurer from within the group, and establish their own threshing run. This second option allowed the farmers to start threshing more promptly, without waiting their turn for a custom operator.

In the picture, the separator tender is standing on top of the machine to oversee the entire operation. Directly in front of him is the weighing device that determined the farmer's threshing bill. The weighing mechanism was usually set to trip when one half bushel was accumulated (16 pounds of oats), then the grain would slide down the pipe to the bagger. The trip operated a tally, so after the last bundle had gone through the machine the tender could call out what the farmer's bill would be. If the farmer had 1800 bushels at .02 each, the bill would be $36.00. The rate also depended on the grain, as different grains such as wheat or barley had different bushel weights.

In every neighborhood, there were a few families renting farms who did not own a portion of the machine. They were welcomed into the run, for the more business the machine handled, the more profit would be returned

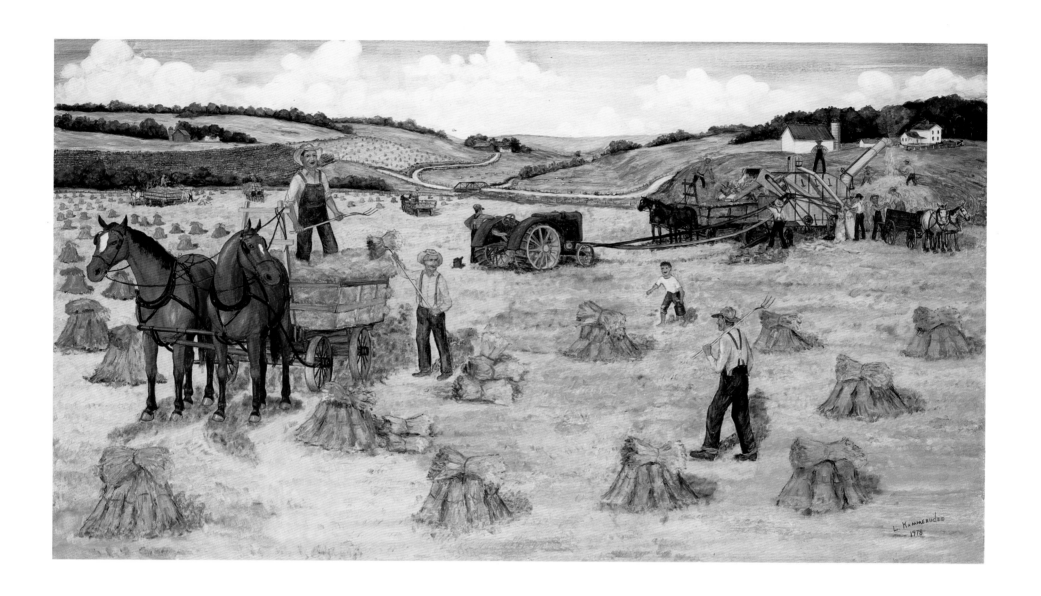

to the owners. To cover a share of upkeep on the machine, renting farmers were charged a little extra per bushel.

Normally a small shed would be built on one of the owner's farms to house the threshing machine while not in use. Only a few farmers owned a tractor large enough to operate a threshing machine at optimum speed. A 30-horsepower tractor was more satisfactory then a smaller 20-horsepower one, and safer for pulling it up and down steep hills from farm to farm. Usually one farmer would be paid for the use of his large tractor and kerosene fuel.

At least a half dozen teams and bundle wagons were essential in most threshing operations, in fact five teams are within sight in this illustration. Most of us who grew up threshing in the 1930s will recall that the most distant farmers would arrive on the job by car then use the team and wagon belonging to the farmer where the threshing job was starting. It was common practice for at least two men from each farm to arrive to help, plus any boys of useful age, for there were many jobs. All brought their own pitchforks. We high school age helpers frequently were assigned the bundle wagon and team of the host farmer. The host farmer had the most miserable job, for he and his hired man or son built the straw stack. That was the dirtiest, most exhausting job.

As the teams arrived in the morning they were directed to the first field. Several men, designated as "pitchers," rode along. The driver stayed on his wagon to load the bundles, with the base of the bundles facing to the outside and the center filled in a cordwood style. The team would usually step ahead without using the reins, as indicated by the foremost team where the lines are wrapped on the "standard." Some men preferred pitching in the field, rather than handling a team, and would continue the same job through the run.

It was rather important that all teams had "check-reins" shortened during threshing, otherwise the horses would shake the shock apart as they tried to steal a tasty lunch of oats. Men assigned a team of mules found that the animals could even drop to their knees to destroy a shock. A young or nervous team might be extremely frightened at first by the noise of the large, strange machine, at least for the first few loads. But gradually they realized that their turn to stand at the threshing machine was the only rest period they would have and soon stood quietly.

The team with the easiest job was the one on the grain wagon. In this example, this is the gray team at the rear of the machine with the high-wheel wagon with the double sideboards. This wagon was backed into the area near the "bagger" to load up the threshed grain for hauling to the bins. One man was required to stay at the double-bagger grain spout at all times. He would fasten the heavy linen bags to the bag clamps. Although the bags would hold three bushels, usually only four or five "dumps" were put in each bag, before shifting to the second spout and removing the first bag. One man lifted the bags to the rear of the wagon box, while a second man stayed in the wagon to move the bags to the front.

After the wagon was filled the team would be driven to the barn to start unloading. Most barns had separate bins to segregate different varieties of grain. If some of the grain was a little damp, it might be spread on a barn floor to be used up first. When a bin was nearly full, it was necessary to keep one strong man in the top of the bin to toss the grain near the ceiling to utilize the entire storage area.

While that team and wagon were off unloading, the "bagger-man" at the threshing machine would continue, leaning full sacks against each other on the ground. By the time the wagon returned, at least a half load would be ready for rapid loading. In the event the straw stack was built adjoining the barn, the team and wagon were eliminated and three or four men would carry the bags to the bins in rotation. Nearly every farmer would have some select variety that would be stored in a small, separate bin to be fanned for next year's seed.

Notice that the men, by habit and for protection, all wore either bib overalls or pants with elastic suspenders, but the little boy with the water jug was wearing clothing more suitable for hot weather. Many farm kids will sympathize with the little youngster running from one "pitcher" to the next with the welcome drink of luke-warm water. Some of us got to ride a pony to deliver the water, even if we had to share room on the tiny animal with a neighbor kid.

Separator tenders had varying personalities and strict methods of operation. For example, some scolded a person unloading if he tossed a bundle into the "feeder" elevator butt first instead of head first. A boss who was too strict became unpopular and was the target for mischief and pranks. The dead skunk found in the field and hidden under the first bundle loaded (and the last unloaded) was a favorite. The unloader would toss the last bundle and the skunk into the feeder, grab the lines and hurry his team back to the field. When the skunk hit the revolving rollers, shakers and sieves, the last of the horrible smell would be extracted from the skunk. During repairs or lubrication of the machine for the next several days, the "tender" was unavoidably reminded of the crew's mischief by a strong lingering odor.

Dinner for the Threshing Crew

Perhaps a retired farmer is not the most qualified person to write the story of a threshing dinner. Yes, I ate a lot of them, but I did not prepare a single one. Some lady senior citizens were delighted to assist in reviving these memories.

At noon, or shortly before, the separator tender would motion to the driver of the waiting bundle wagon that they were going to close down when the present wagon was unloaded. The waiting driver would unhitch his team, take them to the water tank and then to an empty horse stall for hay and six quarts of oats each.

All others would take the cue and start unhitching and caring for their teams. Soon there were no more stalls available, so several teams had to be tied to vacant wagons, with feed and water provided. Some farmers brought halters along, while others simply pulled the bridle over the horses' ears and let the bit out of each horse's mouth so they could eat without the metal obstruction. Once the teams were cared for, the farmers and hired help headed for the house for the noon meal.

A bench was set up in the lawn with an adequate supply of warm water, wash basins, soap, and several towels. Everyone tried to wash off the accumulation of chaff, dust, and sweat from the forenoon's work. In this painting, the "first table" is being seated and served on the porch although it is probable another table was set up in the dining room.

In our threshing run, the "Shady Dell" run, we had about nine or ten farms. With two men from each place, plus a few youngsters, this meant feeding around twenty-five men and boys. To prepare and serve the huge meal, some neighbor ladies would arrive to help. The women also needed to eat after the men had finished, so the total served was about thirty people.

Earlier in the day, the host lady had gone to the basement to pick a full dishpan of potatoes from a cellar bin. These required peeling, boiling, and mashing. Many other items were brought in directly from the large farm garden.

Most likely, the host lady had asked neighbor wives about the type of meat served on previous days in order to be able to vary the threshers' menu. Meat loaf, or canned pork or beef were common, but some ladies realized it was a good time to get rid of a couple of geese or turkeys, which were too large for a single family to consume in one or two meals.

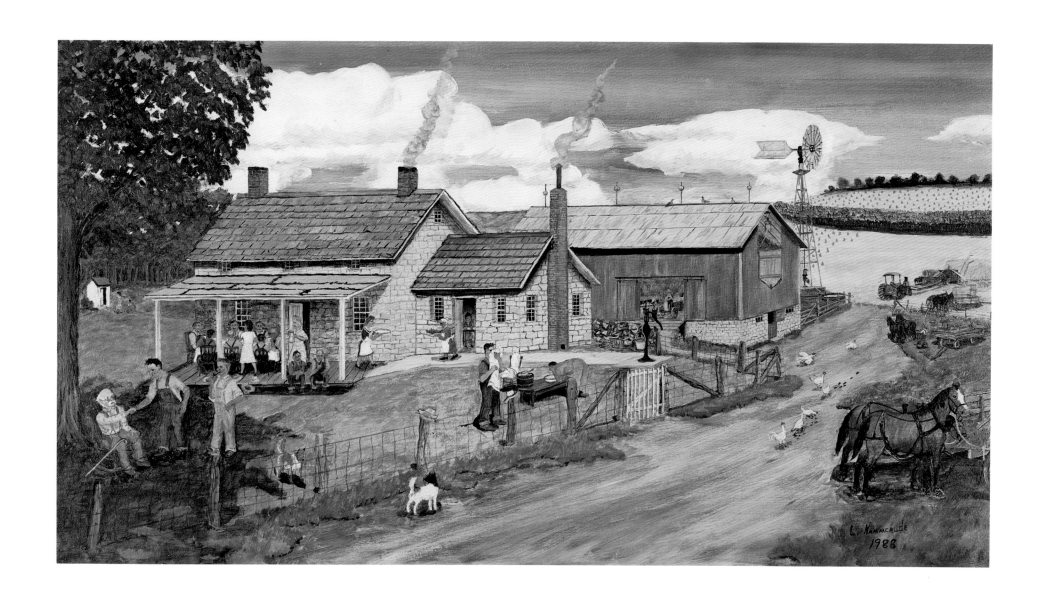

It was considered a big deal to go to the meat market in town the day before to buy a big chunk of beef, packed in ice. Even in the Depression years, some farms would serve good beef, although this was considered by most to be an extravagance.

I remember once my dad went out and slaughtered a lamb of around ninety pounds, and we served mutton. This was not very common in those days and I am sure some of the threshers thought it a little strange.

In some neighborhoods, dividing lines might be drawn over the question of diet. There was a time when Catholic and Protestant farmers were somewhat reluctant to be in the same "run" because Catholics required fish on Friday. Nowadays this is less a source of community friction, but at one time people were very sensitive about forcing those of differing religions to conform to their diet of the day.

For dessert, at least five or six pies were necessary. Apple and cherry were favorites, and always there was more than one kind. Gooseberries and blackberries also were available for pies in threshing season, having been picked and canned by this time. Sometimes a freezer of homemade ice cream would "top off" the pies.

Hungry farmers were not at all embarrassed to take second helpings and they were always offered. The expression "to eat like threshers" was one we understood well.

While each farmwife was not equally talented at preparing such a big meal, the assistance of neighbor ladies helped make the quality of the meal about the same from one place to the next, at least in our run. Generally the food was plentiful and to field workers it always tasted good after a long morning of hard labor. The visiting women were probably the hardest critics to please. They were more likely to notice the cleanliness of a neighbor's kitchen, her skills as a cook, or her preparedness for the big meal.

My favorite place to eat a threshing dinner when I was a boy of ten years old was either Rilla Wilkinson's or Anna Yeidy's. I came along on the "run" to drive a team, although I often tried my hand at "pitching" as well. Both those women always made a special fuss over me and let me come in and sit at the first table with the big guys. I felt pretty grown-up then. At home, my mom made me wait until everyone else had cleared out, and then I could eat.

As the farmers at the first table progressed from ravenous to over-stuffed, they would leave the table and wander over to the shade tree on the lawn to lie down and relax. The ladies would clear the tables, refill the bowls, and the second group would start their meal. It was only after the crew was fed that the ladies could relax a bit and enjoy their own meal. Many of those ladies also had to wash little youngsters and get them presentable after a morning of vigorous play.

After the meal was finished and farmers had relaxed for a few minutes, the tractor was restarted and operations resumed. The three men in the barn driveway unloading a wagonload of bagged oats will have a slightly different schedule. They will finish unloading, bring the empty wagon back, take care of the team, and then join the second table or possibly eat with the ladies. That way the threshing operations could start again without delay, and these men could take a break after dinner, too.

The ladies still had huge stacks of dishes to wash. The extra leaves in the table were removed and stored and the floors swept. Possibly the hostess would have a horse and buggy and would take a couple of other neighbor ladies home before returning to any chores she had left undone that morning.

Some early threshing crews served supper also, but as dairying became more common the chores of evening milking required farm families to return home sooner.

No doubt every neighborhood differed somewhat in customs regarding the threshing dinner, but it was always a social event shared by the families. Notice the elderly gentleman seated in the rocking chair under the shade tree. Yes, he is too old and crippled to share in the work, but he is enjoying the visit with those younger neighbors he watched grow up. He is probably telling everyone who will listen how hard he worked when he was young.

Steam Power

This painting depicts a somewhat earlier threshing scene. Here, an old-fashioned steam-powered tractor is hooked up to the threshing machine. Elderly farmers alive today may have seen threshing rigs like this when they were relatively young, but were probably not old enough to be an operator. Mr. Kammerude himself admitted he was only old enough to be allowed to drive the team on the tank wagon.

Simply, the steam engine on a tractor like this used the expanding pressure of steam to drive a piston. The piston forced wheels to revolve. The huge steel "fly-wheels" served in turn to drive the belt pulley. As the fly wheel developed a high number of revolutions per minute, it provided smooth power, in case several bundles were thrown into the feeder at once.

A steam engine like the one pictured here was seldom owned by an individual farmer. These were owned by custom operators who traveled around the farm communities to do threshing and shredding. The farmers would build huge stacks of bundles, with the "butts" or ends of the stalks facing out, for shocks would deteriorate before the threshing equipment arrived.

Notice in the painting that a small pile of coal has been dumped on the ground behind the engine. Very likely a team and wagon is on the way to the nearest railroad warehouse to obtain a fresh load. Wood was seldom used for fuel in the smaller, portable engines. It was essential that the operator get the fire going early in the morning so that water could be heated to boiling point by starting time.

You will notice also a steel "tank wagon" parked beside the rear wheel of the engine. Very rarely would a farmer have sufficient water available to fill the tank. Therefore, the tank wagon would be pulled to a local pond and several men would wade in, stationing themselves within reach to pass buckets to fill the tank. It was necessary to scoop water gently to prevent sediment deposits, which would eventually plug the valves.

By present standards the steam engine was a clumsy, time-consuming piece of equipment. It had a very crude steering mechanism, the brakes were not sensitive, and there was always an element of danger with a fire of this size that straw might be ignited. Most operators were very cautious in this regard. They seldom felt comfortable close to buildings, as the painting indicates. The exceptionally long drive belt also was a safety precaution. This belt was made of canvas with applications of tar applied to keep the belt from slipping on the steel drive wheels.

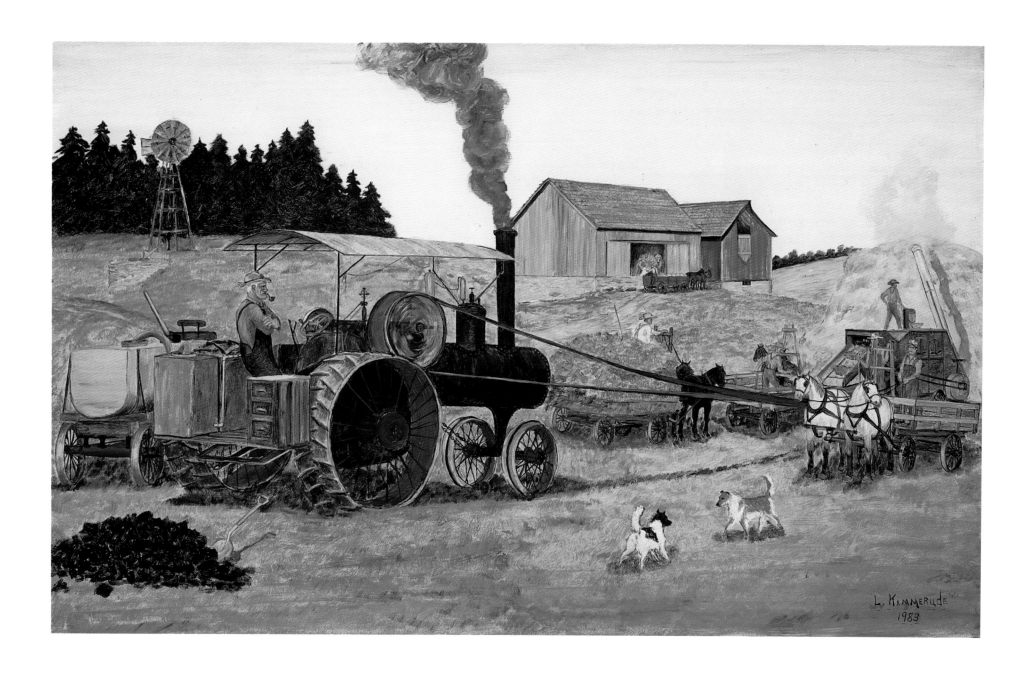

Steam-powered threshing rigs were used in Wisconsin from the late 1800s to shortly after World War I. While wheat was once the ''king'' crop of the mid-1800s, by the 1900s Wisconsin farms had diversified. Probably the most common grain being threshed in Wisconsin in the early decades of the 1900s was oats, with some barley. As the most popular feed grain for horses, the oat crop was as important to the farmer then as corn is today.

It should be noted that these steam-powered tractors had other uses of importance to Wisconsin farmers in this era. They were necessary equipment, for instance, for the steady campaign to improve local highways. Good transportation was essential to the farmer who had to get his produce to markets. Dirt roads were a problem as heavy rains quickly turned dirt to impassable mud, causing all travel to cease. Gravel was the cheapest and most available material to improve the roads. These steam engines were used to drive rock crushers. The road-building operations moved from one local quarry to the next as the roads were graveled. Each township would wait its turn and rock-crushing would continue winter and summer. Many rural men looked forward to this work as temporary employment during slack farm periods, while others would follow the equipment from job to job.

Let us remember that all farm produce sold to an outside market eventually had to be transported in some manner. Cattle were driven first to local stockyards. Hogs were loaded on steel-wheeled wagons with high stock racks, and a caravan of teams delivered them to the same stockyards. There they awaited shipment to large cities for slaughter. All of these shipping yards were on railroad lines. A steam-powered locomotive would stop several times each week to transport the livestock. Other local farm produce such as eggs, wool, cheese, and even maple syrup found its place on these trains, with refrigeration if needed provided by local ''ice houses.''

Steam power continued to play its role in rail transport for years after the huge steam tractors used in threshing were replaced with gasoline-powered ones.

The County Fair

Probably few celebrations have changed less over the past fifty years than our county fairs. Occurring in late August and early September, these gatherings were a chance to display the fruits of the harvest and show off prized livestock. A fair also encouraged a farm family to set aside time, while the weather was still pleasant, to relax and enjoy a brief respite after the hard labors of long summer days.

The grandstand, buildings, and landscape depicted here seem to include elements from the three fairgrounds nearest to Mr. Kammerude's farm: the nearby Green, Lafayette, and Iowa County fairs. The activities shown are typical of county fairs for earlier decades, but a few aspects, such as somewhat modern harness-racing equipment, seem more recent than in other paintings.

Horse-racing has long been a favorite pastime for country folk in Wisconsin, and Lavern Kammerude himself kept a few horses for this sport. At county fairs, harness-racing is very much a family hobby, with drivers and grooms often getting involved at young ages. Within a given region, nearly all the participant families would get to know each other quite well. They enjoyed meeting and competing season after season at the various fairs.

It is obvious that the grandstand is filled with an appreciative audience. The judges and announcers are in the elevated stand with the wire stretching across the track to the amphitheater. The first horse's nose to come under the wire was the winner of that "heat," with the time measured with a stopwatch. Between heats a wide drag was pulled around the track to smooth the surface dug up by the hooves of straining trotters and pacers.

In the grandstand hundreds of people will be filling out scoring sheets—betting who will win the next race. Youngsters will circulate through the stands collecting the sheets, then a drawing is held in the judge's stand. The lucky person who selected the winner will receive a locally donated prize.

Horses are assigned to different races by age group or capabilities. Notice that while one race is being finished, other horses are being hitched to "sulky" racing carts in preparation for the next one. The facilities for stabling the horses are rather modest here, though more permanent ones may be nearby.

For the youngsters, the old-fashioned Ferris Wheel and Merry-Go-Round will be in nearly constant motion. For present-day fairs, the entertainment rides are brought in by professional companies who specialize in providing midway amusements. Liability insurance has caused local fairs to discontinue using their own equipment.

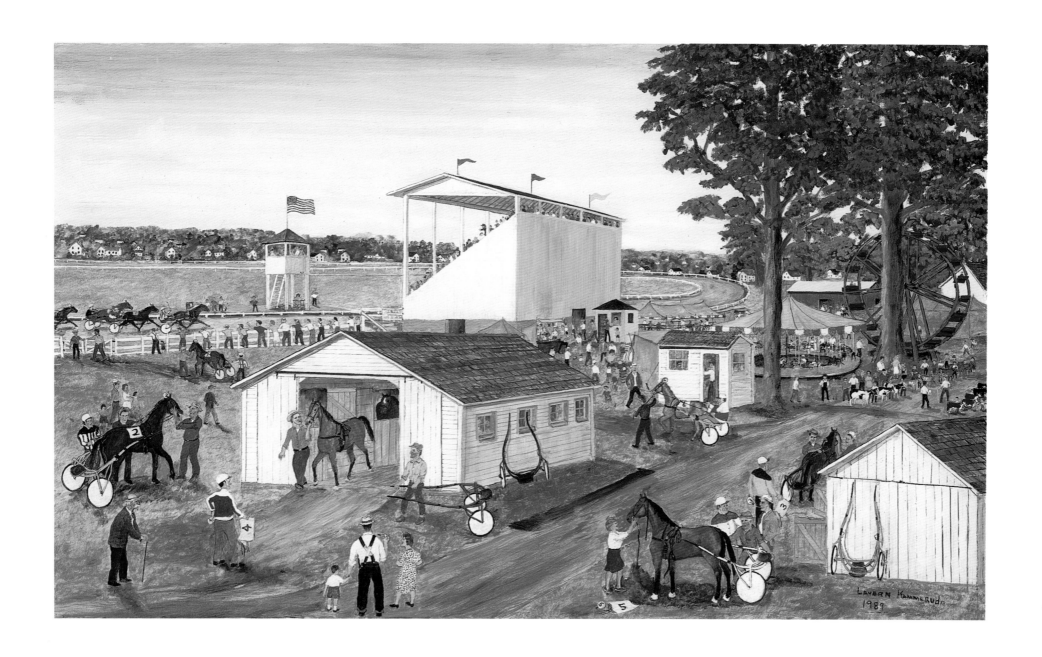

Livestock exhibits continue to be one of the most fundamental portions of a county fair. You will notice two classes of young cattle being judged under the shade trees. All fairs continue to receive state aid because of the educational environment of the competition. Most fairs have junior exhibit classes for youngsters enrolled in 4–H and F.F.A. programs, plus an open class for adults.

Not only is the selection and care of animals of importance in the judging, but also the preparation of the animals for show. Calves must be clipped and properly groomed. Hogs must be weighed early in the season, then reweighed before the show to demonstrate acceptable gains. Sheep are now shown completely shorn of wool, a more honest appraisal than the old practice of "blocking" the fleece to obscure any defects.

The facilities for dairy cattle, beef animals, swine, sheep, and goats are usually kept very clean, and farm people always enjoy strolling through the livestock building to view the exhibits.

As the number of farmers in our population has dropped from twenty-six percent during World War II down to under three percent presently, one would suspect that interest in fairs would also decrease. This is not true. Today, many active 4–H members live in villages and towns. Cats, rabbits, exotic poultry, and pleasure horses may be judged along with the more traditional livestock categories.

At the old county fairs, farm women often had their own competitions. Here, the finest canned goods were shown, with colorful and artistically packed jars of vegetables, fruits, and pickles proudly lined up for display on rows of tables. Pie and cake baking contests were also popular. While judges scored and often got to sample the various delicacies entered, it was wise to remember that the competition was fiercely viewed. Farm women took great pride in having a wall covered with ribbons won for their homemaking skills.

Along with the old-fashioned displays of crops, vegetables, and fruits, today's fairgrounds also have huge halls to exhibit crafts, art, clothing, educational booths, and many other items that require skill and talent to prepare.

Often breeders of registered livestock will exhibit large numbers of animals at a fair. The prize money is seldom enough to make a real profit. Yet having a cow selected as Grand Champion can bring in thousands of dollars above normal market prices. Also, many potential buyers visit the shows to look over outstanding herds.

In today's fairs, the meat animals exhibited in the junior classes are usually sold at auction. Often local businessmen show their appreciation for the young farmers of the area by purchasing these excellent animals at prices considerably over normal markets. Winners also receive publicity in local papers, and their awards in F.F.A. and 4–H are frequently determined by the quality of fair exhibits.

For the old fairs, most families packed a basket lunch to have a picnic in the shade. Many civic organizations now

have food booths at fairs. Run by volunteers, the booths generate considerable income to help with whatever community service the particular club is involved with.

In addition, a section of the grounds is now designated for commercial exhibits. These give machinery dealers, seed companies, and farm-supply businesses an opportunity to present their newest products to potential buyers.

County Agricultural Extension, Fair Board officers and a tremendous staff of superintendents for all the program areas work hard each year to make the fair not only educational, but profitable. The cost of maintaining the facility and updating buildings is a constant challenge for a county fairgrounds. Just as farming can be jeopardized by bad weather, so can a fair that has three or four days of rainy weather.

Besides the harness-racing, there will probably also be saddle-racing, as well as afternoon and evening shows with entertainment. Today, events like tractor or horse pulling contests are popular as well, along with automotive events from races to demolition derbies.

Entry fees, admission fees, grandstand seats, and rental of space for commercial exhibits help to pay the costs of a fair. After the fair, a clean-up crew has lots of work in disposing of manure and garbage, and getting the grounds tidy.

No single picture can tell the full story of a county fair, but this one shows competition, entertainment, education, and a wholesome vacation day.

Yellowstone Church

This stately building is the Yellowstone Church of rural Lafayette County, located just a few miles from the Kammerude farm. As with most country churches in this part of Wisconsin, the church is high on a hill with inspiring views in all directions of beautiful surrounding valleys.

In this picture, farm families are arriving in the cooling fall weather, either on foot or with horse-drawn vehicles. It seems that services will begin in a few minutes.

As people of varying nationalities immigrated to the United States it was customary for them to establish a church of their faith as soon as possible. Despite the frugal home life of farm families, they were determined as much as anyone to build the most aristocratic building possible. Irish, Norwegians, and Germans were among the most populous groups in southern Wisconsin, and their churches have maintained excellent records of the original immigrant founders, often with notes as to the parish in the old country from which each member came.

The locally quarried limestone was a favorite building material in the area. Stained glass windows were donated in remembrance of beloved church members by family relatives. The extremely high ceilings were not heat efficient, but they did allow room for a choir loft and the full-length windows. The original rough pews have probably been replaced several times since the structure was first built in the 1860s.

The huge steeple not only attracts favorable attention for miles around, it also serves as the entry way and bell tower. Thousands of wedding parties, pall bearers, and regular church members have exchanged greetings here in the many years of this church's history.

In this scene, note one family arriving with a fancy surrey and team with a special driving harness, while another family is climbing from the farm milk wagon. Notice too the shed to the right where a team could be driven in and tied, without unhitching. Those arriving late would have to be satisfied with the open hitching rail, where they were not sheltered from a shower.

Each rural church also had a very small barn to shelter the horse used by the minister or priest. The horse was probably owned by a member of the church, and feed was provided by other farmers. At that time, rural clergymen made many home calls to member families. The pastor usually needed only a riding horse with leather bags attached to the back of the saddle to carry his religious literature and to pick up groceries.

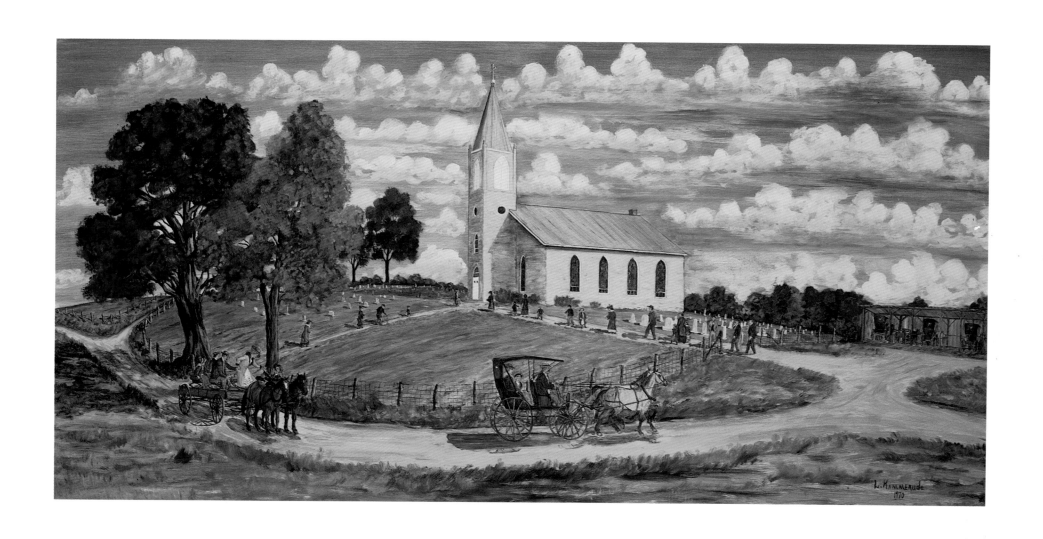

Most families would drive their teams to church, and people became quite familiar with the teams of their neighbors. Just as today a family automobile can easily be identified by neighbors who recognize the make and model, that was equally the case back then. Let me give you an example.

A neighbor, Ben, who lived on a back road from our farm, belonged to a different church than my Dad. One Sunday morning, after a heavy snowfall, Ben's family was trying to make it to early services, but one of his horses fell in a drift and broke the back straps on the harness. He stopped at our place to see if he could get it repaired quickly. Dad suggested, "My team is harnessed, so just take them and I will rivet your harness and use your team to clean barns." Dad did the repairs and old Nell and Floss went to a different church that morning. Within a few days Dad was hearing dozens of comments, "I thought you had sold that team to Ben," or "I thought for awhile that you had changed churches!" A team was so well-known as to be almost a part of the family.

For this church, the cemetery almost surrounds the House of Worship. This was not always true, for the land was usually donated by a member and sometimes a more suitable burial plot would be located a short distance from the church. A special committee was selected to sell plots and keep meticulous records of burials. They also hired the help to maintain the appearance of the graveyard. Many of those ancient tombstones have now been so eroded by weather and moss that they are difficult to read. Still, a walk through an old cemetery is a very real revival of local rural history.

From the painting, we can practically tell the time of day by glancing at the shadows of the horses, tombstones, and pedestrians. Perhaps the old woven-wire fencing of the grounds would be considered an eyesore now, but at that time it was an improvement over rotting rail fencing.

Lavern's grandfather, Ole Kammerude, was involved in the founding of this Yellowstone Church. Some specifics of its history will add to an understanding of country churches in general.

The early Norwegian immigrants settled in that area in the 1840s, but held services at first in log cabin homes or in school houses. A young pastor from Norway, Rev. J. W. Dietrickson, organized the first congregation in Yellowstone and also in nearby Wiota. At that time, each farmer paid one cent for each bushel of grain he harvested to support the church.

Three acres of land where the church now stands were purchased in December of 1863 for $15. The first burial in the cemetery was 1865. The church itself was built in 1868. The list of bills for the first church would seem comical by present standards.

L. Road and Co., Monroe—materials	$814.61
H. L. Nash Construction	2000.00

Extra Labor	491.27
Dodge and Churchill—planing lumber	18.45
John Hendrickson—hardware	52.30
Jones, Dane and Day—welding	16.00
J. Schultz—lime	32.70
H. Bates—rock	2.50
Bills for harvesting stone (local)	464.21

The local farmers hauled the stone from the rock quarry with stone boats. Lumber came from the nearby town of Monroe. Local legend has it that some members raced to California during the gold rush, and if they were lucky, were able to pay their church dues in full with gold nuggets.

The pastor's salary was $150 per year, but he received a similar amount from Wiota. In 1878, a bell weighing 500 pounds was purchased and installed in the steeple at a cost of $50. A Ladies Aid Society was established in 1889 to assist with fundraising, as the church had just purchased $90 worth of carpeting and three dozen chairs for $3! The shed shown in the painting, plus a stall for the pastor's new horse, was built for $114. A custodian for the church also dug needed graves for sixty cents.

About 1890, three congregations, Yellowstone, Apple Grove, and Wiota, joined together to build a parsonage for $3,595.50 plus a new chicken house for the pastor's use. Spittoons were installed at that time to insure cleanliness in the church.

A new organ was installed in 1921. Women were allowed to vote at church meetings and the pastor's salary was raised to $600. Another important change was having one service per month in English rather than the native Norwegian language.

The Kammerudes would want you to know that Ole Kammerude was one of three men who built the steeple. Ole remained on the church board for many years. In 1968 he passed away at the ripe age of 99 years and was buried in the church cemetery.

Silo Filling

This scene probably looks similar to other harvest scenes. A number of farmers are working cooperatively in the fields with their teams. Still, the silo-filling run of early fall was not quite the all-neighborhood event that threshing and corn-shredding were. Compared to other harvest activities, silo filling in the late 1930s was a relatively new task. Many farmers were not yet convinced that a silo met their needs, so fewer farms were involved, and farmers traveled farther.

The concept of the silo was first developed in Europe in the early 1870s, originally in an underground form, and the idea came quickly to America. A farmer in McHenry County, Illinois, developed the first above-ground silo in 1873, but because it was square, silage could not be distributed evenly and spoilage was extensive. Franklin Hiram King, an agricultural scientist, invented the round silo in 1882 and it became an immediate success.

In the early days of silo filling, the corn was not allowed to mature to the degree favored today. If you look closely, you will see white dots in the center of all the corn stalks. The corn plant is being cut when still fresh. The leaves on distant trees have not started to turn color and cows are still grazing.

It is probably late September. At this time, when corn kernels had just started to "dent," silo filling would begin. That practice did save all the leaves on the corn, but today's farmers feel that further maturing of the grain is of more value.

The silo pictured here was the red wood-stave type with metal hoops to control the pressure as the dense silage settled and became a compact mass. All silos were built on top of a concrete pit which usually extended below the barn floor level. It was essential that the entire structure was air tight, for a leakage of oxygen into the moist feed would cause additional fermentation and spoilage. Although the upright stave silo was the first to become popular, such materials as brick, tile, cement block, concrete stave, and later steel would be used in construction.

The green forage provided a very palatable feed for cows in the winter, allowing them to produce at the same rate as in summer. As fermentation took place, the top couple of feet of silage spoiled, but acted as a seal for the silage below. The silo doors, which opened inside the chute for unloading, had to be covered with tar paper to prevent air leakage.

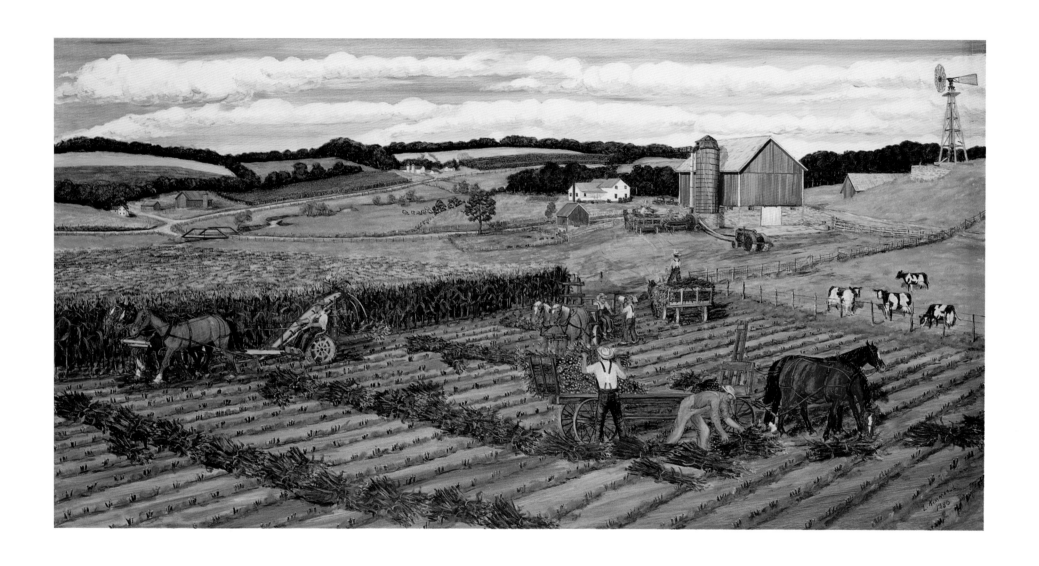

In the winter cows could eat as much as forty pounds per day of this preserved feed. The farmer climbed to the top of the silo and tossed down enough feed for one day, making certain he removed about two inches from the top each day. In extremely cold weather, chipping frozen silage from the silo walls was an additional job.

The main advantage of the silo was the tremendous tonnage that an acre would provide. In the example shown here, the silo was either ten or twelve feet in diameter and no more than thirty-two feet high, including the pit. Yet it would provide twenty cows with silage for about five months, using the corn from only five or six acres. Ten to twelve ton yields per acre were common.

A few hours in advance of starting to fill, the one-row binder was started. Frequently two binders were used for a couple of hours so that longer bundle rows were developed. It was always wise to have a second binder available, for a "break-down" would stop the entire crew.

Although corn bundles were heavy and had to be lifted by hand, the loads were not built as high as grain bundle loads. Note that the "baskets" or sides have been removed from the wagon racks. All bundles were loaded in the same direction, for easy unloading, but on steep slopes a tall load could tip and slide off. There was a crew of loaders in the field so that at least one would be available to help a driver with his load.

The load was pulled up to the silo filler with the butt ends of the bundles facing the feeder. A "spike" pitcher climbed on the wagon to help the driver unload. The machine operator stood near the blower and kept one hand on the apron clutch. If two bundles overlapped it could slow the speed of the tractor down, causing the filler pipes to plug. A pull on the clutch would stop the feeder until the knives and blower cleared. Five minutes would normally unload a full wagon if the power was sufficient. The knives were set so that stalks, ears, and leaves were chopped in one-half to one inch lengths for uniform settling.

A silo of this size could normally be filled in five hours. For the last ten feet, even with a man placed in the silo to level and distribute the silage, it was difficult to prevent the filler pipe from getting plugged up as the roof filled. If feasible, farmers preferred an "over-night settle" as silage might settle as much as six feet in one night. The next morning they could finish filling, then would tear down the silo pipes, load them on wagons, and move to the next farm. The silo filler and tractor would follow at once. New holes would be dug for the filler wheels, the tongue turned under the apron, and the belt aligned and tightened. The binder crew already had moved to the next farm several hours earlier. If more corn had been cut than the silo would hold, the farmer would just toss the last load of green bundles in the pasture for the cattle to devour.

In going over some old farm records, I note that my father had paid the filler operator $17.50 to provide the tractor, filler, fuel, and his labor to fill a silo of this approximate size. For five or six hours work, that was the equivalent of two finished hogs.

If you check the background of this painting you will note one silo on an adjoining farm and—a real rarity—two silos on the farm directly north. There it would be possible for a filler operator to take in over $30.00 in one day's work. In comparison, the hired man in the fields would have been making no more than $35.00 per month, plus board and room, and that "tremendous" wage would drop further during the winter months to about $15.00 per month. Such salaries were typical through the late 1930s.

Additional features are evident in the painting that indicates this was a modern farm for its day.

First, the windmill on the hill feeds into a huge reservoir, so that, during windy weather, water can accumulate. One pipeline runs to the stock tank in the barn yard while a second line would run across the road to the relatively new farm house. Those water lines had to be at least six feet underground so that they would never freeze, but running water at the house was a real luxury.

The second innovation was the sliding door in the end of the barn. That allowed cattle to be stanchioned lengthwise in the barn, and the spreader could be backed in to the far end and manure scooped from the gutter to the spreader without carrying. The team just stepped ahead a few feet at a time as the cleaning progressed. Before this modernization, cows usually came in side doors and manure was carried the full length of the gutter for loading.

Another clue which ties this painting to the late 1930s era is seen in the distant fields with strip cropping for erosion control. This did not occur until the establishment of the Soil Conservation Service which provided farmers with benefits for combating erosion.

The hill-drop method of planting corn for silage is already in use here, rather than the old cross-cultivation technique depicted in an earlier painting. For silage, farmers frequently purchased a variety of corn that grew very tall, but did not ripen early. Then even if there was an early frost, this corn would contain enough moisture to ferment well in the silo.

Presently, this scene has been replaced by tractor-drawn choppers which throw the silage directly into wagons that are self-unloading. These are then hauled to the barnyard where a blower system deposits the material into a much larger silo. Automatic distribution systems keep the silage relatively level and the silage is covered with a seal to prevent spoilage. Most silos today also have automatic unloading devices.

Today, two men with three tractors can easily harvest more tons of silage in one day than could be stored in all four of the small structures visible in this painting. On the negative side, today's equipment would cost a minimum of $50,000.

Rural Free Delivery

The lady waiting at her mailbox is receiving a prized delivery today. The smiling postman is handing her a hefty Sears Roebuck catalogue. Now she can begin to study this to make out her entire Christmas shopping list, except of course for those presents she will make with her own hands.

It seems amazing to consider now, but mail-order products were often delivered in only four to five days after the order was placed in the farm-road mailbox. Montgomery Ward and Sears Roebuck were the two main catalogue companies that served rural areas. Offering products that were difficult to obtain in local stores, they also based their appeal on reliable and speedy service.

In this painting, the corn crop is in shocks, cows are still grazing on pasture, and the trees are showing color. This beautiful autumn day with its crisp air was a delight after the heat of late summer. Even the family dog has chosen to come out to the mailbox to meet one of his animal buddies, the mail horse, that stopped by every workday.

Rural free delivery was first established in 1896. A farmers' organization, the National Grange, was active in getting Congress to provide money for rural mail delivery. The first such deliveries were made in West Virginia, and it was not until 1917 that all rural areas had this service.

The silo indicates an early farm improvement, but the narrow country road would be very antiquated by later standards. Rural mailmen continued to use horses to service their routes even into the 1930s, especially in the winter time, for snow-removal methods on the country roads were quite primitive. Since this is still beautiful weather, the fact that the carrier is still using a team and buggy suggests this is somewhat earlier, perhaps closer to the World War I era.

I can remember in the early 1930s our local mail carrier decided to give up his horse team in the winter and go instead with an automobile with "chains." However, just a few years later in 1936 we had such heavy snow storms that he regretted his decision. At that time I was in high school and was using a team to get myself to town, picking up a few friends on the way. With several other students who drove teams, I boarded my horses during the day at a small barn attached to the local hotel. For much of the winter, the mail carrier was forced to borrow our horses, a different team each day in rotation, to be able to service his snowbound route.

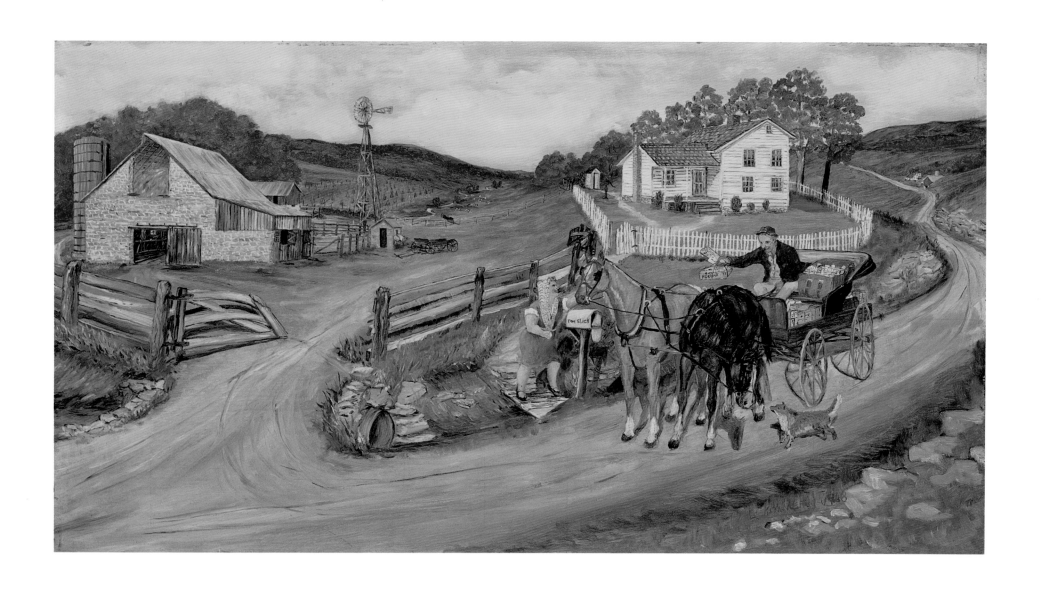

The rural carrier not only delivered and collected mail, but also sold postage stamps, issued money orders, and was authorized to register letters. At the time of this scene, a letter cost two cents to mail and the penny postcard was in use. Ironically, even with rates that sound so low, such large profits were accumulated that in 1910 a Postal Savings System was developed. This worked as a loaning agency as well as a savings account program. Special postal rules were issued in World War I to allow soldiers to send money orders home to relatives.

Very early, the rural delivery system established such regulations as the type of mailbox allowable, the preferred height, and the importance of raising the flag on the box to notify the carrier that there was outgoing mail to collect.

In this picture, the buggy is rather small. It was common for postmen to use larger "surrey" type vehicles that had more protection for the mail in severe weather. In winter, either a sleigh or light "cutter" was used in Wisconsin's cold climate.

Although this team appears fresh and well groomed, they will be exhausted before they complete the thirty-five to forty miles common for a township route. When roads were bad, the rural carrier often changed teams at noon and completed his route on the opposite side of the village post office with fresh horses. Sometimes the local livery stable would allow the carrier to use a team that needed exercise.

Stories are still in circulation about carriers in the winter who would tie their team to a fence and walk several miles across fields to service families on a route when roads were impassable. This dedication probably caused customers to recall the motto of the postal service: "Neither snow nor rain nor heat nor gloom of night stays these couriers from the swift completion of their appointed rounds." In fact, this statement is attributed to the Greek historian Herodotus, referring to couriers in an age long before the rural free delivery.

The farm buildings and fences here are modest, and would probably not meet today's standards for milk production, but for that era they were substantial buildings. Some of us older fellows will be a little surprised to see the tube under the driveway. It was more common in those days to have a rock arch to allow water to flow to the road's drainage ditch.

The old, warped gate has left its mark in the driveway, for the hinges no longer manage to hold it off the ground. Those heavy gates, which had to be dragged open and shut, are familiar memories to many of us. A few of these relics are still standing, separating fields and pastures.

It was common on rural routes that farmers on "blind-end" roads had to place their boxes on the nearest "town" road, so that carriers did not have to retrace any portion of the route, considering their long daily travels. Such farmers frequently had to walk a half-mile or more to pick up their daily mail.

However, there was virtually no mail theft from these isolated boxes, even though they often contained checks from livestock markets or rent payments for those farmers who owned other properties. It would certainly have been difficult to alert the sheriff promptly about any theft, for you will notice no telephone lines running to this farm, although these would be standard a few years later.

Shortly after World War I, as soldiers returned to seek employment, they were given favorable consideration for postal positions. Consequently many servicemen completed their working years in this branch of government service.

Rural free delivery gave its initials to local routes called "RFD." The daily visit of the mail buggy was a boon to farm families. It helped to ease the isolation of farm life and brought farmers into closer contact with the rest of the world.

A Farm Auction

This painting shows an activity which has changed very little over the years. Every rural paper still lists a few farm auctions nearly every week and people of all ages attend. While today's sales techniques may be more sophisticated, the purpose remains the same—to convert all removable farm equipment, livestock, and crops to cash.

This scene takes place in October. The leaves are still on the trees and the corn is in. The sale is just starting. As is true with modern-day auctions, the policy then was to start with a few hay racks loaded with farm tools. The auctioneer and clerk are dressed in suit and tie, which would no longer be typical today. The helper, holding up the articles for bidders to view, is dressed in conventional farm clothes. Notice only one buyer is leaving the wagon with an armload of tools. The low value articles are sold first, for the crowd will increase as the higher value articles become available for bidding. In those days there were no microphones—the auctioneer had to "yell" all day.

Probably the second sale clerk is already set up on the back porch or kitchen to accept the money, give receipts, and verify checks. The clerk on the wagon will send a sheet of recorded sales with buyers' names and final bids to the kitchen as each page is completed.

Many farm people attend auctions with no intention of buying but to keep informed of current values. An actual sale is more accurate than any appraisal. The conditions of equipment or livestock are carefully examined in advance. Note that some people have no interest in the small tools, but are looking at cattle, machinery, or the teams of harnessed horses.

Several women are bringing coffee and food baskets from the kitchen to be sold in the milk house. Most buyers came early and purchased their noon lunch. For modern auctions, a commercial mobile lunch stand takes care of that service. Also, today's auctions have many more ladies who are active bidders. There has been a pronounced increase in the management involvement of women in agriculture.

After the small tools are disposed of, the auctioneer will start moving down the rows of machinery. The selling farmer will give any information about the machinery that may not be visible. In this case the portable wood saw will be one of the first items sold. The grain drill, mower, harrow, corn planter, and grindstone will complete the first row, then they will move to even larger farm machinery.

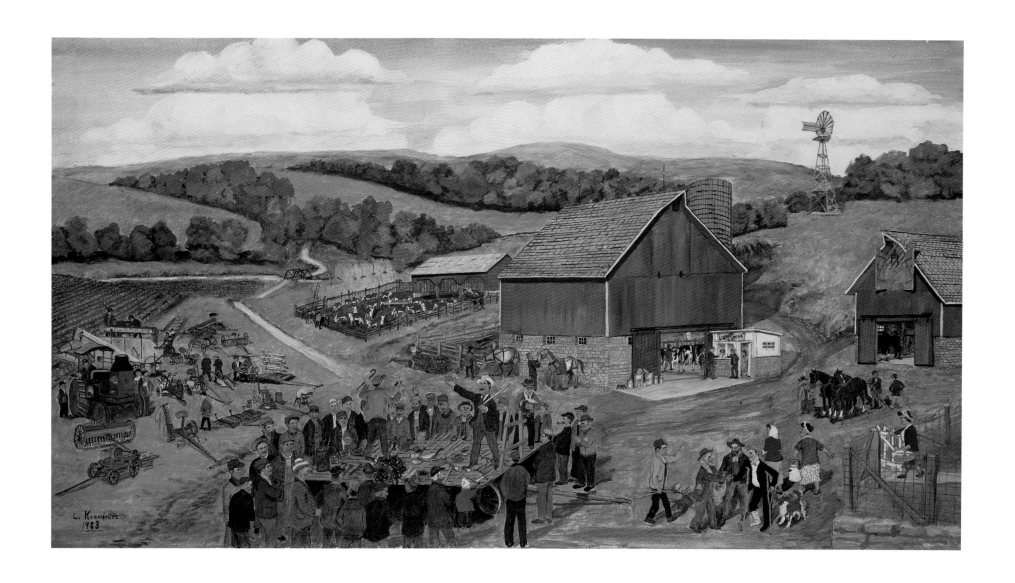

After the crop machinery has transferred ownership, the auctioneer will probably move to the front of the barn where the milk cans, strainers, and milking equipment will be sold. While all the bidders are gathered there, samples of oats, barley, ear corn, and a bundle of hay will be displayed with cards showing how many bushels or tons of each are available. Sometimes the new renter will already have made a deal with the selling owner to purchase the feed inventory, for hauling feed was a slow and time-consuming job. If the feed is offered for sale the new tenant was always a concerned bidder, for buyers usually had about ten days to remove the feed and this time delay could be a nuisance.

As the sale moves on to the livestock some of the crowd will start leaving. This sale will hold a larger audience because it offers both beef and dairy cattle. The dairy cattle will be released from stanchions two at a time. The highest bidder can select his choice of the two, then bidding starts on the second. The crowd will open up to let the purchased cows into the barn yard and two more will appear. After the adult cows are sold the springing heifers, yearlings, and calves will be sold in that order. In those days the herd bull would be led out with two ropes attached to his nose ring and sold separately.

Next they will move to the beef cattle. Even then, there was some certification of herd health provided by the local veterinary, though not the numerous tests and records required today. The Herefords for sale here are likely the brood cows and bull. Very likely the younger cattle, with a constant market value, have already been sold to avoid the sale percentage charged by the auction service to cover advertising, sale service, and collection costs.

By the time the auctioneers get to the two matched teams, the buyers of other items will be standing in line to pay for whatever items they have purchased. The horses will attract quite a few competitive bidders for they are high quality teams.

For each team, with a prior announcement to alert the bidders, the auctioneer will auction the horses twice. First, each of the two horses is auctioned off individually, with a note made of the high bids. Then the bidding begins again on both horses kept together as a pair. Whichever method yields the highest total price for the two horses carries the sale. Many buyers would pay somewhat more to keep a well-matched team together. Before the team leaves the ring the harness and collars are sold separately. Notice that one prospective buyer is examining the teeth of the gray gelding to determine his age.

There were many circumstances which required a farm auction. The most common in those days was the case of an elderly couple who had no children to take over the farm. When the work load became too great, they sold their farm livestock and equipment and retired to town. Sometimes they rented the farm to a young couple or sold directly to another farmer. Frequently, during the Depression years, a loaning agency forced a farmer to sell if he was unable to make payments on his indebtedness. However, there were times during the Depression and later when farmers would

boycott a forced sale to convince loaning agencies to refinance a hard-working farm family who had fallen on hard times.

In other instances, a farming couple might decide to return to a home community many miles away to take over a relative's farm. Rather than move all their equipment, feed, and livestock a distance of thirty or more miles, it was simpler to have a sale and then repurchase whatever they needed closer to the new location.

Farm auctions have nearly always been an honest and prompt method of converting farm property to cash. With a large number of bidders, an opportunity to examine the items prior to selling, and reasonably accurate feed measurements, it was fair for both buyer and seller.

However, there are always a few exceptions to every statement. There are still stories in circulation about farm auctions during World War II. At that time, many pieces of new equipment had prices ''frozen'' by government decree. For example, a relatively new International tractor might have had a set price of $1,125, with dozens of farmers eager to buy at that price. To reach a better price, the auctioneer would announce that a leghorn rooster and the tractor would be sold only as a pair. As a result, a perfectly ordinary rooster might bring in several hundred dollars!

Many farmers showed up at sales as a social event. Notice at the corner of the lawn there is a man on crutches, with two neighbors inquiring about his progress. Even the family dog seems curious.

Perhaps auctions have become more sophisticated from the standpoint of advertising, audio equipment, livestock hauling, and multiple auctioneers. But many of the traditions remain the same, even if today's bidders come from greater distances and are mostly strangers to each other.

The Country Store

Younger persons will appreciate the tradition of the country store, for in some communities they still survive. Today these little establishments provide a rather limited service. When horse-drawn vehicles were the most common means of transportation, however, the country store carried a wide range of products needed by farm families. In those days, these small businesses failed or prospered mainly on the basis of service and the personality of the proprietors.

This scene probably takes place in October. Poultry was traditionally sold in the fall, before Thanksgiving. One family has a couple of crates of live chickens on the outside scales being weighed. At the same time two other families are bringing in twelve dozen crates of farm eggs. Very likely these families had no intention of taking home any cash from these sales, but will shop for groceries until the poultry credit is gone.

The needs of customers then were different than those of present-day farm families. Flour for bread making came only in fifty-pound bags. Sometimes smaller bags of whole wheat flour could be purchased for "Grahams Bread." When the flour came home it was dumped into a kitchen flour bin and the high-quality linen cloth sack was used for garments. In the event of high winds, which lifted little girls' skirts, the flour-sack "bloomers" became apparent.

Probably most of the wagons and buggies are carrying empty kerosene cans. In this still mild weather, kerosene was used for small "oil stoves." A simple meal could be prepared and the stove shut off without overheating the entire downstairs of the house. Remember also that nearly all lighting in the home was by kerosene lamps with wicks, although some folks might have had a fancy gas lamp or lanterns.

Frequently ladies brought in other produce in addition to poultry products. It was not unusual to see the lady in the store "stemming" gooseberries or washing up some turnips which had been bartered for other groceries.

Country stores seldom carried ready-made clothing in those days. Instead, they carried bolts of cloth and a limited supply of lace so ladies could make up a needed garment. A few bib overalls were usually in stock.

There was also a shelf for drugs, many of which would now be considered "quack" remedies. There were many cough medicines, hair restorers, baby powders, and iodine disinfectants in stock. Two items which were absolutely essential to carry were chewing and pipe tobacco. Possibly the beautiful Appaloosa saddle horse, tied at the hitch rail, was galloped to the store to replenish the tobacco supply.

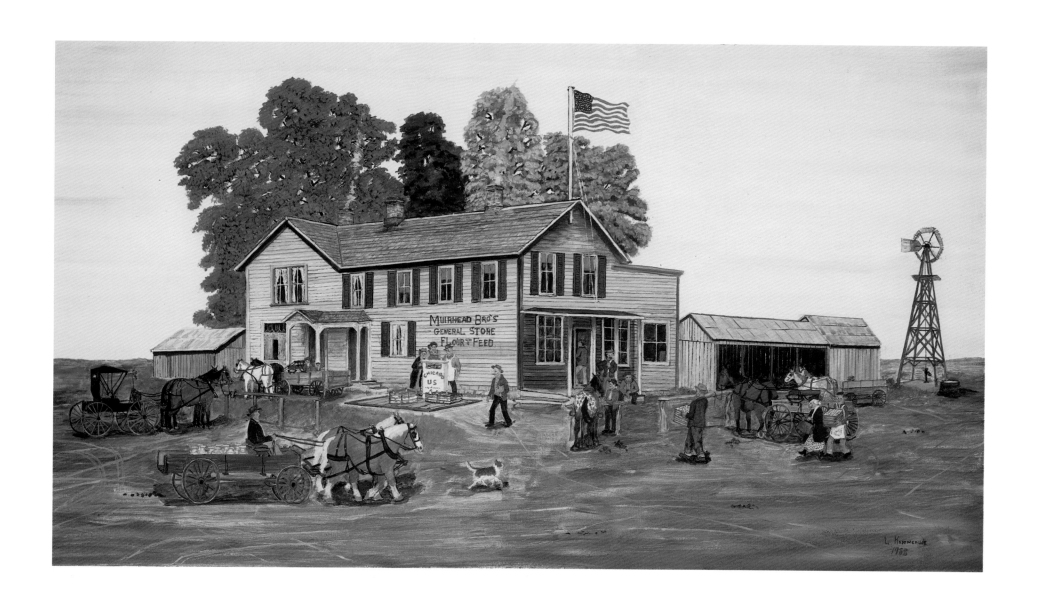

In the winter time, if roads were blocked by snow, it was quite common for one farmer with a good saddle horse to call a few neighbors on the party line to see if they had emergency needs. He would make a list, then ride through the fields to get to the store, fill the saddle bags with small items, then deliver them as he returned.

Quite often the old shed behind the store would have a foot-pedal grindstone that was faster to sharpen a dull mower sickle than the small hand-crank one at home. It was sometimes worth driving in to pay a dime to use it.

The owners of the local store usually lived in the upstairs, so if there was some emergency need, the customer simply knocked on the door and the store would be reopened. Most Saturday nights these stores stayed open late to take care of any needs for the Sunday dinner the next day.

The owner of the store shown here also handled feed. A high percentage of sales in those days was related to poultry, such as chick starter, laying mash, or oyster-shell grit. Stores also carried block salt for cattle, plus loose salt in bags which was used for freezing homemade ice cream as well as a feed additive. If the store was near a large stream, the proprietor might harvest blocks of ice, which were stored in a shed insulated with sawdust. In most homes, the ice box was replenished at least twice per week so that perishable products could be stored.

The practice of gathering around a potbellied stove in the country store to chat about the local news is still going on in some areas, but was even more common then. The store owners usually had a huge pot of coffee on the stove.

Some of the items carried in those stores in early years would not be recognized now. Although they usually did not stock harnesses, country stores normally carried sweat pots, hame straps, tubular rivets for splicing broken straps, and an assortment of metal bridle bits. There would also be a variety of rope bales which would be sold by the foot to make halters, replace halter ropes, or repair hay loaders.

A few basic hardware supplies were normally in stock. Kegs of nails, fencing staples, brace wire, sickle section rivets, and buggy whips were available.

Owners of country stores were not offended when their customers went to larger cities to do major shopping for the family. In fact, they did the same to meet the needs of their own family. They were simply providing a service to meet basic needs of their local friends and neighbors, and they did it very well.

Corn Shredding

Corn shredding was one of the least popular harvest jobs. It was done late in the fall, perhaps November, when winter chores were already heavy and the days were becoming shorter. In normal years most farmers harvested not more than 25% of their corn crop with a shredder, for it was labor intensive work.

The corn shredder was developed to use the entire corn plant. The shredding machine separated off and husked the ear of the corn for quality feed, and shredded the rest of the plant for fodder (used as lower-quality roughage feed or as bedding for livestock). In fact, if a farmer had an exceptionally good harvest of hay and oats, providing plenty of hay and straw, he was likely to elect to eliminate the time-consuming corn shredding job that year.

One additional reason to dislike corn shredding was the element of danger for the man standing on the feeder platform. His job was to grab the corn bundle from the farmer who was unloading his wagon, then cut the twine string off the bundle and spread the stalks for even feeding. The feeder had rotating arms to pull the stalks in. If the feeder man lost his balance, he could easily be injured seriously.

The corn plant went through the machine, the husks were removed from the ear, and the stalk was shredded into six-inch segments. The whole ears would be elevated to a waiting wagon, while the lighter fodder was blown into the upstairs of the barn. If there was any excess moisture in the corn plant, the fodder would usually heat up and steam in the barn after a few days.

The painting indicates a day's harvest at the beginning of the shredding season. Depending on the weather, if a farmer was on the tail end of the shredding run, he might have to take a team and long log-chain to the field, drop a loop around the base of each shock, start the team and pull the imbedded corn stalks from the frozen ground or snow drifts. This was not a fun job. Usually it was the policy in a neighborhood to start one year at one end of the community and work to the far end. Then the next year that rotation was reversed, so that the same farmer would not be last in line each year.

A corn shock contained approximately 100 "hills" of corn, around 250 to 300 stalks, when planted with the old horse-drawn planter. Usually the corn was cut with three horses on a binder and the bundle carrier allowed the bundles to be dropped in a uniform pattern. That way the shocks were in straight lines for convenient loading. It was important

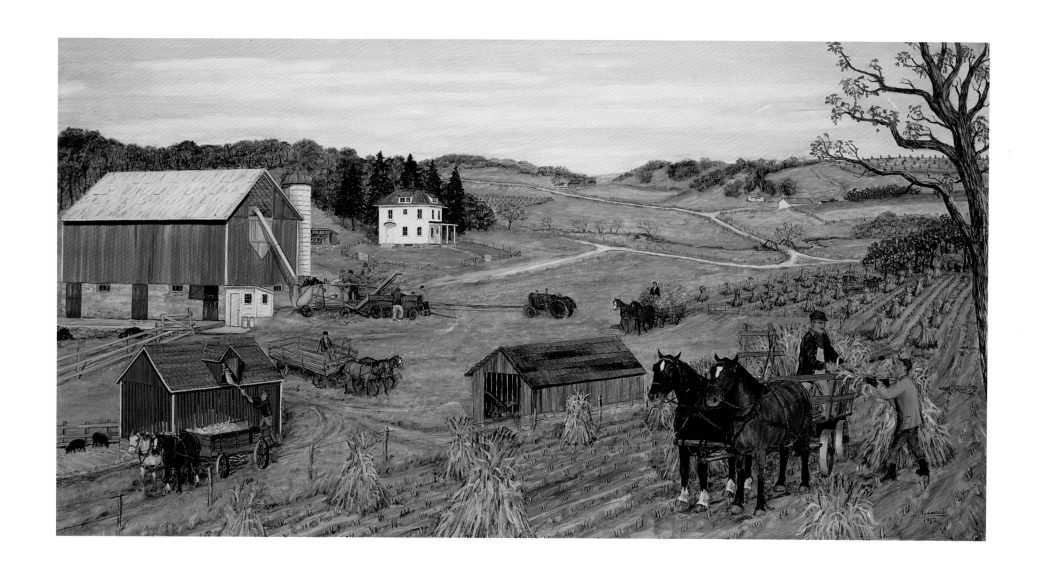

that the harvesting be done after the ears were mature, but before the leaves shattered. It was also essential that the corn dried in the shock for a few days before shredding began.

During the depression and drought years of the early 1930s, many farmers and unemployed laborers returned to hand cutting and shocking the entire crop. For this task a "shocking-horse" was used. This was designed with two front legs, similar to a sawhorse, with a light pole attached with the far end resting on the ground. A hole was drilled about three feet from the front end of the pole and an iron rod inserted midway through the opening.

As the laborer cut each hill of corn with his corn knife, he would stand the stalks against the rod in the shocking horse, then repeat as he circled the shock, keeping a uniform pattern. When the 100 hills were cut, the farmer would take a piece of binder twine, usually carried in a pail, tie a loop in one end, circle the shock and insert the base end through the loop. The twine was then cut, pulled as tight as possible, and tied to keep the shock from tumbling down. The iron rod was then removed, and the horse pulled from the center of the shock and moved to the next work area.

Handcut corn like this, not in bundles, was awkward to work with but the financial condition of the farmers in those years gave them little choice. The shortage of feed made it necessary to salvage everything.

The alternate method of harvesting dry ear-corn in those days was hand-picking. There were a few very skilled pickers who could pick as much as 100 bushels per day and shovel their own loads, but the average farmer with other chores was proud of a 50-bushel day. After the corn was hand-picked, young cattle or sheep would roam the fields to pick up dropped ears and eat the standing fodder. Corn shredding as depicted here did utilize the entire crop to better advantage.

It took a sturdy young man or two to do the job of shoveling the ears of corn into the crib to be stored over the winter. The corn wagons had a hinged end gate, called a "shoveling-board," which would be unlocked and dropped to floor level so unloading could begin at the rear of the wagon. It was important that the person unloading could shovel either left or right. The team would be backed several steps during the unloading to stay in alignment with the crib openings.

After unloading, the now-empty wagon was returned to the shredder. The team was unhitched from that wagon and rehitched to a full wagon. For a few moments the shredding operation would be stopped to prevent ears spilling on the ground during the wagon change.

As the team drove off with the full wagon, two or three farmers would roll the empty wagon back under the corn chute and the shredding would begin again. Usually an older farmer would stay with the wagon by the shredder to level the load of corn and motion for help when it had to be rolled ahead.

As a corn crib became almost filled, it was necessary to have one person inside the crib to keep the crib opening clear and roll corn into corners to make certain the entire capacity of the crib was utilized. In a slatted crib, snow could blow across the corn unless the sides were completely blocked.

Farmers usually used lighter teams for shredding, as indicated by the painting. The loads were not extremely heavy and the trips of neighbors to distant farms could be accomplished faster than with heavy draft horses. Those teams had to be well trained and obedient, for the lines were simply wrapped around the hay-rack standard most of the day as loading continued.

There were always several extra men used as ''loaders'' in the fields. They cut the outside twine on the shock and lifted the bundles to the man on the wagon. The bundles were usually stacked upright, starting at the rear of the hay rack and working toward the front. From seven to ten shocks normally made a full load.

Operations were always shut down at noon. The men came in and washed up at the kitchen sink and had a huge, hot meal. Several neighbor ladies would come in to prepare and serve the meal. Since days were short and chores at home were heavy, most shredding runs did not serve an evening meal. If a job was nearly completed several farmers might stay a little late to finish so that the machinery could be set up at the next farm early the following morning.

When the job was done, the shredder operator would move the tractor ahead slightly, remove the long drive belt and roll it up. Next he would hook the tongue of the shredder to the tractor's draw bar and move ahead very carefully a few feet. Then the blower pipe could be free of the barn opening and cranked around to lower on brackets for moving. All hinged parts were folded and locked in place. In extremely cold weather it was necessary to drain the tractor radiator, for antifreeze was not yet utilized in tractor motors. The next morning it would be refilled with water and then moved to the next farm with perhaps one half hour to block wheels, align belts, grease equipment, and refuel.

A House Party

This scene can be dated by the homemade calendar under the wall clock. It is December of 1927. Farmers were prospering at that time, as was the rest of the economy. Two years later, with the "Crash of '29," these same farmers would suddenly find themselves in dire financial straits. Still, parlor dances continued through the Depression as an inexpensive source of neighborhood fun.

House parties could be called for any number of reasons. One unhappy but common reason, especially in the Depression, was a "going-away" party for a family that was moving. Sometimes the family was leaving to buy another farm, more often they were just renters who were moving to another place, sometimes not very far away.

Another excuse was a "house-warming" dance for new neighbors moving in. It was important to get acquainted, for these rural farmers would soon be working together over the coming year.

A party would also be held as a congratulations for a young couple who had just announced their engagement. Probably this dance was not for that purpose, for there are fewer teen-age participants.

Occasionally dances were held in country schools. One drawback to these was that rural school boards sometimes were reluctant to allow neighbors to show up with a jug of homemade wine, an event quite acceptable at a house party. Notice the glasses happily being filled by the host in the kitchen.

Most often, however, the only excuse for such a farmhouse dance was that a week had passed since the last one. In many rural neighborhoods, dances were held once a week from the end of the harvest in the fall until spring planting was ready to begin. These parties rotated around the neighborhood. Favorite spaces included good-sized parlors, especially one with a pump organ or piano. Even a large kitchen with enough space for a set or two of dancers could be used for a house party.

This particular farm parlor in the painting seems to be of enormous size, perhaps a trick of memory. When most of the furniture had been carried to another room or out onto a porch, farm parlors did indeed look much bigger, especially to young participants, than they did in everyday life.

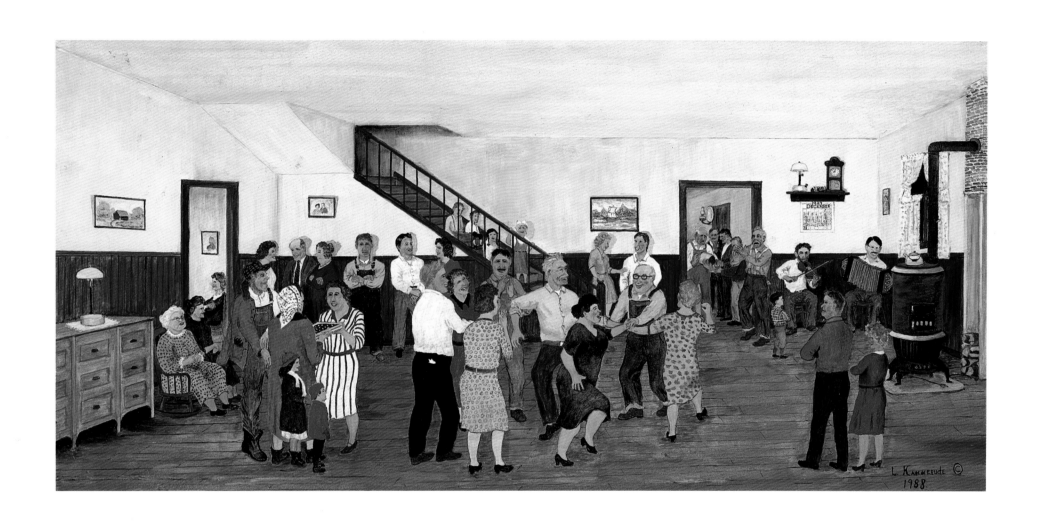

Housewives who elected to host such parties realized they might have some repair work on the floors after a night of dancing. Notice the old pine "tongue-in-groove" flooring in the main room. This would be waxed before the dance, but floor wax was much softer then and farmers' shoes frequently had been resoled with nailed half-soles. The leather wore down faster than the nails, which left tiny scratches all over the floor surface after a night of dancing. If the floor was to be restored to its original condition, this meant removing the wax, varnishing the floor, allowing a couple of days to dry, then rewaxing before rugs and furniture could be returned to the room.

Note that many of the men were not convinced that they should dress up to the same extent the ladies have. Their idea of "dressing up" is to wear their least faded pair of bib overalls. Remember, though, that in December they had driven a team of horses to the party and had to blanket them—sometimes with double blankets—after tying them to the nearest fence. Probably there are also some coveralls stacked in the kitchen. The ladies and children often found the ride across the snowy fields quite enjoyable, nestled deep under piles of robes and coverings.

As a contribution to the evening, many women brought cakes or cookies to share. At some point in the evening, the dancing would stop long enough for a light "lunch" of coffee and sandwiches.

In nearly every rural neighborhood there were a few self-taught musicians who enjoyed playing for these dances. Often the music and dancing continued from dusk until dawn broke the next morning. One fiddler and one accordionist would not seem quite adequate by today's standards, but for a farmhouse parlor dance this provided lively accompaniment. If it was necessary to get musicians from another neighborhood, the local men would place a mason fruit jar in front of them at the dance and toss in coins to show appreciation.

Probably the old wood stove that is glowing now will not be refueled. In fact, perhaps a window or two will be opened to cool things off as the activity increases.

Even though the crowd is still gathering, the first group has started a square dance. A "caller" would sing out the rhythmic instructions for the dance. The terms "allemande left," "square through," "birdie-in-the-cage," and "star right" are traditional calls familiar to many. There were a number of other dances popular then, such as the Waltz, Circle Two-Step, Turkey Trot, and Fox Trot. Some wild young person even might demonstrate the Charleston. The Polka was popular in some areas, as was the Schottische. These were often called "round dances" as the dancers traveled around the room.

Such a party was a place to teach youngsters the common dances. I myself recall as a teenager learning the Circle Two-Step. My tutor was an enormous housewife who clasped me with a powerful grip and did not allow me much opportunity to lead. I just hung on, and was very glad when that dance was over.

Notice some of the youngsters still sitting on the steps. They were probably put upstairs to go to sleep, but crawled quietly down the stairs to watch the dancing through the stair rails. In just a few years they will be old enough to join the dancing.

The smallest youngsters enjoyed the party for a couple of hours, then an older girl would herd them into a vacant room and get them settled down for a nap. Often they did not awaken even when after the dance they were bundled into winter clothing and driven home in the sleigh. But at home after such a long nap Dad and Mom may have had a bit of trouble getting them settled again in their own beds at home.

Notice also the youngster standing attentively watching the musicians. If he had saved a little money doing odd jobs that year, he might be contemplating placing an order for a mail-order violin. These were available for only three or four dollars through the Sears Roebuck catalogue. With a few months of winter left to practice, that same young fellow might be sawing out a simple tune like ''Golden Slippers'' on his own new fiddle by the time spring arrived.

In contrast, the elderly persons attending would not participate in the dancing, but enjoyed the chance to visit. They had ''dibs'' on the rocking chairs in the room. Sometimes these were elderly parents who had reluctantly retired and moved to the local village, turning over the farm operation to younger members of the family. This was their chance to see neighbors on the farm again for an evening of friendly togetherness.

Note there are two gas lamps illuminating the room and no kerosene lamps are visible. It was a real sign of affluence to own two. My guess is that one was borrowed for the evening and that all other rooms had the simple kerosene wick lamps.

A neighborhood event, the house party dance disappeared over the decades as farms became much larger and more independent, and as the interests of age groups grew more specialized. Wall-to-wall carpeting became popular in farm homes, eliminating rooms suitable for dancing. Some 4–H clubs have revived the old square dances and now perform on wagons during Dairy Day parades or local talent contests. Adult square-dance clubs also meet to relearn the dances of the past and practice more complicated moves than those known to most of the participants at a house party.

Yet memories of those old neighborhood ''house-party'' celebrations always bring a smile to the face of anyone who took part in them.

Wood Cutting Bee

This winter scene shows neighbors working together to saw firewood. The harvesting of wood was not solely for use during the cold months. Consider for instance that throughout the entire year the old kitchen range had to be fueled with split wood. Certainly, however, the Wisconsin winters were the main cause of large woodpiles being gobbled up, as wood-burning stoves and furnaces did their best to keep farmhouses warm and cozy through the coldest time of the year. This required many armloads of wood, as those who had to carry it will recall.

In this painting we are observing only the final process of wood-cutting, in which the poles are cut into blocks. There had been many weeks of labor before this final activity. For a wood crew, there were fewer men involved compared to threshing and shredding. With heavy farm chores and shorter daylight hours, often such a crew would operate only in the afternoon. Sometimes, however, they would assemble earlier, if it was necessary to take the portable saw mill to a distant woods.

There were a number of factors in the selection of wood used for fuel. Every year in a timber lot a few trees die, either from lightning or disease. Those would be used first, since they were dry wood. To cut large timber, two men with a cross-cut saw were needed to drop trees and cut them into sections. A well-shod team then skidded the trees to a clearing where branches were cut off and the trunks cut into manageable lengths. Also, it was safer to have two men present, in case of an accident. The bigger logs were then split with wedges, so that a couple of men could lift them.

Another source of wood was generated if the farmer had cut a number of saw logs to provide lumber for a needed farm building. All the largest branches and any crooked logs not suitable for lumber were available for fuel. In this case, it was necessary to dry the wood for a year.

A third possibility was that the farmer needed farm land more than timber, so he would "clear cut" about one-fourth acre. The first year or two, that piece of new land would be used as the family potato patch, until the stumps could be removed and the land added to a field.

Also, every section of timber had some "weed" trees like box elder or wild cherry that had little value. Although not so popular as fuel either, these trees were still used.

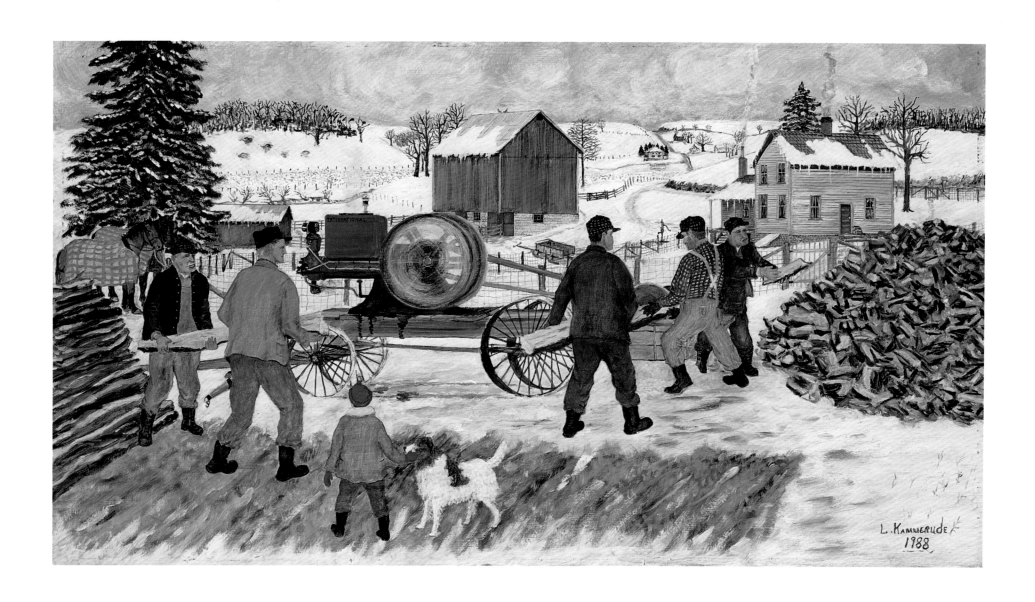

Some farmers with lots of unneeded timber would contract to supply wood for a rural school or to residents in a nearby village. If an old farmer had retired to town, he might come back to his family on the farm to help cut wood, then would borrow a team to haul some of the fuel to town for his own use.

When wood was to be sold it would be cut in four-foot lengths and priced by the cord. A cord was a stack four feet deep, four feet high, and eight feet long or 128 cubic feet total. A common price was $4 a cord delivered, but not sawed in blocks. Most buyers preferred oak wood.

In the scene portrayed here, the pole wood has been hauled and stacked near the buildings. For this, farmers usually used a bobsled with side stakes in the frame so that a large load could be hauled. It was wise to stack the wood carefully, otherwise a heavy snowfall would make it very difficult to get at it again to saw it up.

The man with the plaid shirt and suspenders is the owner of the portable saw. Very few farmers owned a saw rig, so the owner often drove as much as eight miles to perform this service. He would trust no one else to feed the logs into the saw, and he didn't need a ruler to cut almost exact fourteen-inch blocks. This size would fit nicely into the firebox of a cookstove.

The circular saw shown here was a very early model. It does have a safety shield under the bottom half of the blade, but the top half is exposed. In the early 1930s a protective cover with a spring was installed on the platform so that as the pole was cut the shield would be forced back, but the spring would return it to cover the dangerous whirling blade. This device saved lots of injuries from falls or pushing too close. The stationary gasoline motor probably generated no more than five to seven horsepower. In fact, the operator usually had someone help turn the two huge iron "fly wheels" to start the motor. It was the momentum of the fly wheels which furnished the needed power as the cutting was performed.

Notice that the team is blanketed and tied to the fence. This, too, was a safety factor. It would have been easier to keep the horses hitched up to move the saw frequently and avoid carrying more than necessary as the men advanced down the pile of stacked wood. The problem was that if the team remained hitched and a piece of bark or a "knot" flew through the air and hit a horse, it would jump forward and someone could be injured. Instead, in a very short while this group will shut off the motor, hitch the team, and move ahead a little to be closer to the remaining wood. Perhaps the operator will take a few moments with his flat file to touch up the saw teeth, although he had sharpened it and reset the teeth before coming on the job.

At the same time another couple of gallons of gasoline will be placed in the fuel tank and a few squirts of lubricating oil aimed at the bearing.

Circular saws were in use on farms even before mounted gasoline engines became common. In those earlier days, a horse-powered sweep was used to provide power. Two or three horses walked in a circle, pulling a small beam around a central gearbox which provided power to a saw mill outside the horses' path. Each round, the horses had to step over a ground-level drive shaft which led outside the circle to the saw. The farmer provided the extra horses for that task. This method was not popular since the equipment was cumbersome to move.

In this scene, the little boy and the family dog have decided to observe this noisy operation. After the stove wood has been split, this same little boy will spend many nights before supper making certain the wood box is full. He can use his hand sled now, but later the old coaster wagon or his tired arms will be put to use.

Some farmers hired the sawmill man to come back a second time during the year to sharpen posts. This required changing the blade from a cross cut to a longitudinal cut. Small posts were sharpened so they could be driven into the ground with a sledge hammer for minor fence repair. Otherwise, full-size fence posts required digging a hole and tamping the post solid.

Old farm records from the early 1920s show the cost of sawing a winter's wood ranged from $18 to $21. This did not include the exchange of help with neighbors, or the many days' labor getting ready for this final operation. Even if the total cost had been $100 for a year's fuel it would seem slight when compared with electricity bills of $200 and more per month on present-day farms.

This painting also shows one other small detail of agricultural history. At least one farmer is wear "husking gloves". They were a unique pattern with each glove having two thumbs. After a day of severe wear, the face of a pair of work gloves would start to shred. With the extra thumbs, they could be turned over, reversed to the opposite hand, and the user got another day's wear! A pack of a dozen pairs of work gloves cost $1 so it was essential to get full use from them.

This scene with its nearby buildings, hard-working farmers, and snow-covered landscape recalls an old adage that "the man who cuts his own wood is warmed twice."

A Winter Day

Judging from the amount of hay already cut from the large haystack back by the barn, this painting shows a winter day in perhaps January or February. With his sheep-skin lined coat and ear flaps, the farmer is starting off for the cheese factory to deliver the milk.

It must be an extremely cold morning, for a horse blanket has been tossed over the cans to prevent the milk from freezing before delivery. Several days have passed since the last snowfall, as the walks and roads are not drifted and escaping heat has melted the snow at both the peak of the barn roof and the uninsulated house, causing a shift of the snow cover toward the eaves.

The housewife is pumping water, probably to refill the hot-water reservoir on the rear of the old wood kitchen range. Very likely she is pumping water from the cistern, which accumulated the run-off from the house roof. Most farm women preferred that soft rainwater for laundry purposes. The drinking water would be carried from the well at the windmill.

The youngster carrying the split wood from the pile in the backyard to stack on the porch probably was assigned that job as a regular chore. If not, he was the one who got into mischief that morning and it was his punishment. Some senior citizens of today may even remember doing that chore by lantern light as a result of teasing a little sister. Smoke is coming from the chimney of both the kitchen range and the pot-bellied heating stove, both of which have been refueled within the past few minutes.

Although it is an extremely cold morning, a few cows are drinking at the stock tank, so it is probable the tank heater was refueled this morning also. This heater was seldom enough to keep the entire surface of the tank ice-free, yet it allowed the cows to get at the water. Also, it kept the old metal "float" free of ice. The float was attached to a ball valve to prevent the tank from running over. Otherwise, a tank overflow caused the area to become so slippery that cows were afraid to come to the tank for a drink.

Note the man up on the hay stack working to fill the huge mangers. The tall hay stack was built during the summer by using a huge tripod of three hay poles. At the peak of the tripod, a pulley was attached and the hay rope inserted. Another pulley was placed at the base of one pole, then a hay fork was attached to one end of the rope and a

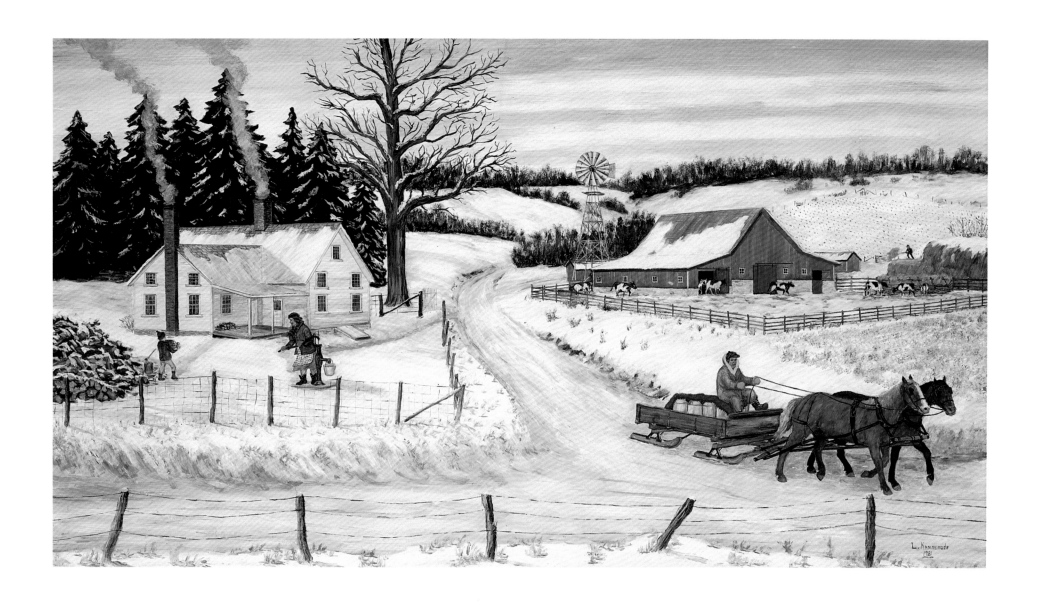

gentle horse on the other. With the filled wagon of hay pulled as close to the poles as possible, the man on the wagon would plunge the two tines of the old-fashioned harpoon fork as far into the hay as possible. Pulling up two levers caused hinged barbs on the points of the fork to grip the load.

He would then call for the kid with the horse to lead or ride just far enough to hoist the hay up near the peak of the tripod. As the fork-load of hay swung in the correct direction, a trip rope was jerked and the hay fell on the stack. Another man on the stack with a three-tine pitchfork would then distribute the hay, building a uniform pile that would not tip, yet shed rainwater fairly well.

The picture here depicts the cutting of feed from that hay stack. To prevent the entire stack being exposed to the weather, a hay knife was used to cut a segment, perhaps eight or ten feet long. The knife was about two and one-half feet long with large, sharp, serrated teeth. After a cut was made across the stack, the spoiled material on the top was removed and the good hay tossed down in the manger. After a couple of weeks, this segment would be cut down to ground level and a new cut started on top again. You will note that the milk cows are coming from the barn to eat the choicest hay. After they are returned to their wood stanchions, the dry cows and young cattle will be turned out to spend the day lunching on the remains.

The style of barn shown here had too little hay storage area on the upper floor to meet the needs of a herd the entire winter. The limited storage was used for very choice second-crop hay and the corn fodder.

After that spirited team of horses returns from their brisk trot to deliver the milk, they will probably pull up to the barn doors with the sled. Last night's accumulation of manure will be forked and scooped into the sled. During extreme cold weather there was too much risk of breaking the apron chains or beaters on the old wheel-driven manure spreaders, so instead the manure was taken to a distant field and spread by hand using a five-tine manure fork. The floor and sideboards of the sled will be scraped clean before the ugly stuff freezes solid.

On the way back, they will stop at the straw stack to pick up the day's livestock bedding. That afternoon the team may be required again, this time to go to the timber lot and return with another load of wood to replenish the supply before a big snowstorm closed the lanes with drifts too deep for even an agile team.

This picture shows the entire family at work, but with youngsters in the family, there is a strong possibility this same family will be involved in fun activities tonight. Again the team will be hitched, perhaps to travel to a neighbor's farmhouse to while away the long evening with the excitement of square dances and circle two-steps.

Maple Sugaring

The maple sap "run" of the months of February and March is a traditional harvesting of one of Wisconsin's sweetest crops. With snow on the ground, yet sun in the sky, the men in this picture will have a busy day going from one tree to the next to collect the buckets of light golden sap, filled drop by drop over the past hours.

Maple sugaring is among the oldest food-gathering activities known to inhabitants of the state. Even before white settlers arrived in the region, Woodland Indian tribes were using maple sap to make sweet syrup. The Indians collected the sap in tightly-sewn birchbark baskets from gashes cut in maple trees. To cook the light liquid down to a heavier consistency, they placed heated stones into the sap, held in either larger birchbark containers or wooden troughs. The heat from the stones evaporated the water until the sap became thick syrup or crystallized sugar.

Today's large commercial operations have now gone to miles of plastic tubing to transfer sap to huge evaporating set-ups. Mechanized equipment is used to drill holes and insert sap spouts or "spiles." With these stream-lined methods, Wisconsin now ranks in the top syrup-producing states in the country.

This painting depicts a small commercial operation, possibly around the time of World War I or after. During both World Wars, the local production of maple syrup and maple sugar soared because of sugar rationing. Since then, commercial production has continued strong in northern Wisconsin, while fewer operations still exist in the southern part of the state.

More commonly, farmers in this part of Wisconsin will recall "tapping" only a few trees, pouring buckets of sap into a large container on the old wood kitchen range to cook down. This produced enough syrup to cover many stacks of pancakes. Homemade syrup might last most of the year if the farmer was well prepared for the run and had a good stand of large-sized maple trees.

The timing of this operation will not be exactly the same each calendar year. Maple sugaring usually occurs sometime in the period from mid-February through the end of March. The sap begins to flow best when the weather warms well above freezing during the day, yet cools down at night to below freezing. The season stops when the night-time temperatures no longer fall as low, and leaf buds begin to form on the trees.

Curiously, a south-wind will also bring a temporary stop to the sap's flow, even though the temperature factors are right. A season usually lasts about twenty days, but can be as short as four days, a real disappointment in terms of the amount of syrup produced.

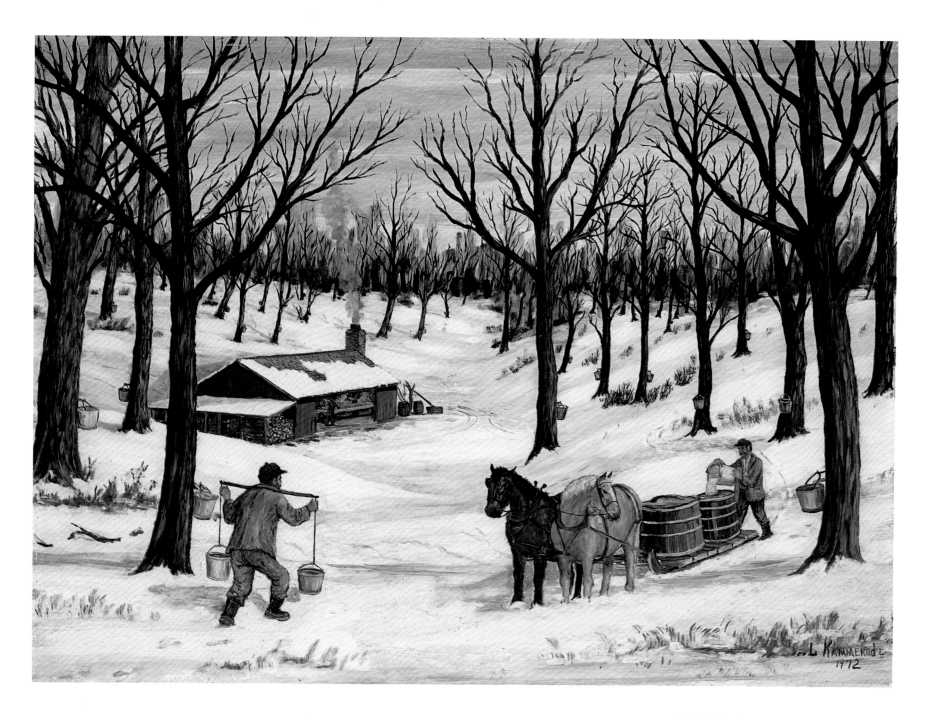

The pattern of trees in this maple grove seems so regular that it would appear to be a hand-planted area. This is not true. Instead, the natural stand of maples has just been thinned methodically over the years. All "weed" trees like box elder and basswood have been removed and used for fuel to fire the evaporator equipment.

Trees are not tapped until they have a diameter of over ten inches at waist height, while large trees over twenty-five inches in diameter may have four or five taps. A single tap-hole often produces from forty to eighty gallons of sap, with different trees having a wide variation in sugar content. "Hard maples" or sugar maples are favored, but "soft maples" like silver maples also produce a good yield, with a slightly different flavor.

You will note the team is hitched to a "stone boat," a very low sled, so that buckets of sap do not require high lifting. A layer of cheese cloth or flannel is placed over the wooden tubs to filter out any foreign material. These wooden tubs or vats may seem old-fashioned, but they continued to be used because the chemical reaction or any rust in a metal tank would have destroyed the flavor and color of the finished syrup. It was very important that the gathering buckets contained no solder on the seams. Today, plastic containers are used.

This trip through the maple grove is likely to be one of two for the day. The buckets need to be gathered before they overflow and waste the precious drops of sap. It is possible the last collection will be done by lantern light.

Tapping a tree requires a 3/8-inch hole bored three inches deep through the bark and into solid wood. The hole is drilled with a slight downward slope. For the "hobby" operator a wood auger was generally used for this. The tapered "spile" or sap spout is tapped in gently so no splits or leaks are caused. Although all spiles are metal or plastic now, it was once common for them to be made from straight branches of elderberry or reeds with hollow centers. They were cut in about eight-inch sections and whittled to tap easily into place. The present metal spiles are quicker, but do require careful cleaning and dry storage. The old-fashioned wood spiles were made each year, probably on a stormy winter day when the farmer was forced to sit indoors with little else to do. The metal spouts have a hook to hold the bucket in place, as shown in the picture, otherwise an extra nail is hammered in to hold the bucket under the dripping spout.

After the season was over, the spiles were removed, but no plug was put in the hole. Natural growth would cover the hole within a year, although it did leave a scar. Today, a germicidal pellet is put in the hole to prevent insect and bacterial damage. Each year a new tap will be placed at least six inches from the previous tap and a spiral pattern will be followed around the tree as the harvest years continue. Many believe that a tap on the warm southern side of the tree produces more sap.

In a busy "sugar bush," or maple stand, the best way to carry several buckets at once and keep the liquid from spilling while the worker plodded through deep snow was to use a short balancing stick, carried on the shoulders, with a pail hung on either end.

As the tubs are filled, the team will move them to the "sugar shed," where they are emptied into a large open tray. This tray is heated, with a man to watch the fires and make sure the sap does not boil over. It is important that the evaporation process starts at once, since the sap can lose flavor and color if it is stored long, and it should not be allowed to freeze. Large amounts of wood were needed to keep the fires going for many hours to cook down the sap into syrup.

A gallon of syrup should weigh eleven pounds, while water weighs eight pounds. Today, there are fancy instruments to measure exactly the solids content of the syrup. In an earlier period, a wire loop about two inches in diameter was placed in the "finishing pan" and if a film of syrup remained on the loop when lifted, the evaporation process was completed. If a batch was overdone a small amount of sap could be added, or the process could be continued to produce sugar.

There is a tremendous difference in yield, but on an average, thirty gallons of sap are needed to produce one gallon of finished syrup!

The labor requirements were heavy for those few days of maple sugaring. On the other hand, for an operation of this size, few crops produced a greater cash income. The farmer certainly appreciated that the same crop could be harvested again the next year without replanting or fertilizing or other time-consuming care. Also, maple sugaring occurred in late winter, when there were few other tasks that could be profitable. At this time of year, most of the timber and firewood harvesting was already done, but farmers could not yet get into their fields for spring planting.

When old maple trees passed their peak production years, they were cut down and sold for lumber, making sure the cut was made above the old tap-holes. New trees would be allowed to grow up into the spaces created.

Sweet Clover School

For the farmer, the year begins again each spring. This scene is nearing the last days of school in late April or early May. Cows are grazing in an adjoining pasture and a farmer is completing his grain seeding with an old "broadcast" seeder. For many of us, this painting will rekindle fond memories as we compare the Sweet Clover School with the ones we attended.

Judging from the model of car parked in the entrance, this picture could be dated in the late 1920s or early 1930s.

In those days, each township was divided into rural school districts, each of those covering about six square miles. In a country school like this, one teacher performed all teaching chores for the eight grades enrolled. Sometimes there would be one grade that had no students, but that was rare. In rural areas there was frequently a change in student enrollment on March 1, as that was the month farmers on rented farms moved to new locations and children had to become acquainted with another school.

That one teacher was responsible as well for keeping the building clean, starting the furnace fire and keeping it fueled, and supervising playground activity. Those who attended rural schools will recall that washing blackboards, beating erasers, and sweeping were frequently performed by students who were caught whispering or speaking without first raising their hands. Without these chores assigned as punishment for misbehavior, the teacher's work load would have been tremendous.

Teachers were typically young ladies who had taken a year's training after high school in a rural teacher training program. Not many years earlier, a much shorter program of only a few months was required to teach. Until the mid-1930s, no married ladies were allowed to teach, as they had husbands to support them. The prevailing opinion was that single ladies needed the employment. Spinster ladies frequently devoted their entire lives to rural teaching.

It was customary for the teacher to room and board with a family in the district, hopefully close to the school so that she could walk in early to get the fires started. If her parents' home was not too far away, she would try to get home weekends. That was even more important if her "beau" lived in her parents' locality. At the time of this picture, teacher salaries were about $65 per month, and that was a sizable increase from previous years.

Children normally started first grade at five years old, unless the family lived so far from school that the walk would be too difficult—then it was delayed a year. One of the first things beginners had to learn was that boys went to

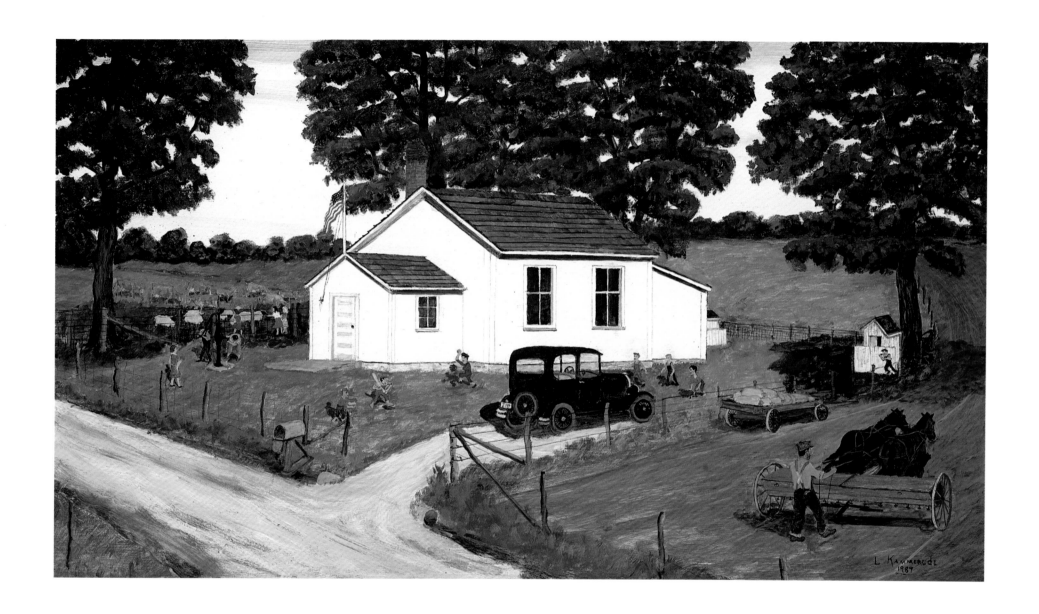

one "back-house" and girls to another. That was not the same as it had been at home. Older students provided this vital information.

These back-houses, by the way, were the same ones that were traditionally tipped over on Halloween by roaming teenagers. The morning after Halloween the school board members usually showed up at school to set the back-houses up on their foundations again.

Three board members were elected in a district and usually all were men. They made the decisions on what teacher to hire, and if she would be rehired. They made out the checks for salary, arranged the purchase of wood fuel, determined what repairs would be made on the building, and kept hand-written clerical records.

Many districts established a hot-lunch program by the 1920s and 1930s. A mother would take her turn and show up about eleven o'clock with soup, cookies, and other lunch items. She would tie the team to the teeter-totter or fence, then come in to get the lunch heated before noon recess. Usually this was only in the cold months. During pleasant weather kids carried a sack lunch or a dinner pail.

During the school day, students would have fifteen-minute classes in rotation. Each class would file to the front of the room facing the teacher's desk and be seated on a bench. They frequently had to go to the blackboard to demonstrate answers to questions. All students could hear the classes reciting and younger children became acquainted early with difficult subjects they would later cover. Older students often helped tutor younger students with their lessons. The noon hour and fifteen-minute recesses were always ruined by the clanging of the school bell!

The desks for the older students had a hole designed for an ink-well. Students learned writing skills with a pen holder and pen point combination. There were no fountain pens or ball-points. Each student started school with a supply of "penny pencils" which had very small erasers. Later we got the conventional pencils with a metal band holding a large eraser, but they were two for a nickel. It did not take long to grind them down to stubs in the pencil sharpener on the back window sill, even if you did have to raise your hand for permission to crank that fancy machine.

Throughout the year, supervising teachers from the county made visits to each school to monitor educational progress. Students who did not master subjects at their class level were held back for a repeat of that grade. Conversely, exceptional students were allowed to skip a grade. The final test for eighth graders was administered by the county to determine if a student was prepared for high school.

Perhaps twenty years prior to this period, it was typical for boys to attend school only until spring farmwork started, then drop out for the remainder of the year. For that reason it was not uncommon for the older boys to be approximately the same age as the teacher!

Young readers may feel this was a very crude educational environment, yet there were virtually no students who could not read or write. Perhaps the amount of one-to-one instruction encouraged youngsters to excel. Older students were very tolerant of the younger pupils and helped them in many ways. Mothers came to visit school frequently—an important day for the young children especially.

In the spring, there were rural school "play-days" where softball teams competed with other schools, and children became acquainted with kids they would later meet in high school. Within the immediate neighborhood, the country school was a very real community center. Not only were the Christmas programs well attended, but social clubs and literary guilds often met there for their programs.

At least once each year a "basket-social" was held to raise money for some needed equipment. Each mother and girl brought a box lunch and an amateur auctioneer sold the dinners to the fathers and boys for the highest price. Little boys were sometimes a bit embarrassed to have to sit at the same desk with a girl to have lunch!

In the winter, the school board usually bought cordwood from a member of the district and after many bobsled loads were hauled, all the fathers came in with a portable saw mill and "blocked" the wood. From that day on, students had no sled-riding at noon until all the blocks were taken into the basement and stacked to the ceiling. The young ones carried it in and the tall boys did the cording.

During the winter, if a severe blizzard started during the day, several dads would show up with teams and sleds to haul the kids home—or at least to the mailbox, as some farm driveways could be nearly a mile long. In normal weather most youngsters walked to and from school, even if they had to cross fields and pastures as a short cut.

Some of us might be a bit jealous of this school, for it has a well and pump. In my school, from fifth grade up we had to take our turn, by weeks, going to the local spring to fill the water bucket and return it for drinking and washing purposes.

Notice little boys are wearing bib overalls and little girls very plain dresses. The boys were much more comfortable in their school clothes than on Sundays when they were forced to wear "knickers" and long stockings to church.

In the summer the grass in the school yard grew rapidly with no traffic, so some nearby farmer would be hired to mow with his team and rake it with a dump rake. In dry years he was glad to do it free of charge for it produced a day or two of feed for his cattle at home.

EPILOGUE

Spring turns to summer, and summer to fall. The new seeds being planted by the farmer next to the Sweet Clover schoolyard will germinate, and grow tall, and be harvested. The small lambs being petted by the children will grow into sheep, perhaps to be exhibited proudly at a county fair.

And as the years go by, the children of the Sweet Clover School will grow up too. Some will go off to live in towns and cities. Others will stay and follow in their parents' footsteps to become a new generation of farmers. In turn they will plant and harvest, nurture livestock, and watch their children grow up.

Anyone raised on a Midwestern farm in the 1920s and 1930s will look back on these paintings with a twinge of nostalgia. Gone are the days of neighborhood threshing rings. Disappeared too are the house parties, the country schools, the woodcutting bees, the threshing dinners, the prized teams of work horses.

The scene of the Sweet Clover School happened to be the last painting that Lavern Kammerude completed. A man who painted things he knew well, he finished it only the day before he died in the fall of 1989.

If there is a special heaven for Midwestern farmers, it is a place where there is always some work to be done, for a farmer does not like to sit around with nothing to do. There, horses are robust, the grain grows golden, and all work goes as planned. By day, the heavenly sky is blue with fleecy clouds. Rain comes only at night as the farmer sleeps—and never when hay is lying cut in the fields.

Lavern Kammerude left a precious legacy: these colorful memories of farming in the days of threshing.

Wisconsin Folk Museum

APPENDIX
Paintings and Collections

The following is a list of the original paintings by Lavern Kammerude included in this book by special permission. These twenty-one images, created 1968–1989, are only a portion of his total work. It is not known how many paintings he made during his career from the mid-1960s to his death in 1989; the total is believed to be between 200 to 300.

It should be noted that, on occasion, Lavern Kammerude would paint similar versions of the same scene. For instance, he painted various scenes with schoolhouses, cheese factories, hay-fork horses, threshing dinners, and evening milking chores.

Some of these repeated scenes are nearly identical ''copies'' of his own compositions with only minor changes. Other times the versions show significant variation in buildings, characters, or backgrounds. Kammerude's varied repetition of certain images was often in response to a request by a person who had seen his work and wanted to order a specific scene. Perhaps the customer would request a particular element added or changed. Lavern often added extra touches on his own initiative to personalize a variant, as he often knew the customer as a neighbor or friend.

All of the paintings are oil on masonite. Dimensions are given to the nearest inch.

Spring Planting (page 19), 1980, 16 " × 28 ". Collection of Gerald Regan.

Blacksmith Shop (page 23), 1979, 18 " × 30 ". Collection of Richard Nelson.

Cheese Factory (page 27), 1977, 18 " × 32 ". Collection of Gerald Regan.

Haying Time (page 31), 1977, 18 " × 24 ". Collection of Gerald Regan.

Milking Time (page 35), 1981, 18 " × 24 ". Collection of Gerald Regan.

Belgian Power (page 39), 1985, 18 " × 28 ". Collection of Gerald Regan.

Threshing (page 43), 1978, 21 " × 36 ". Collection of Gerald Regan.

Dinner for the Threshing Crew (page 47), 1988, 16 " × 28 ". Collection of Gerald Regan. A similar image is in the permanent collection of the Wisconsin Folk Museum, purchased with funds from the Mount Horeb Community Foundation.

Steam Power (page 51), 1983, 16 " × 25 ". Collection of Gerald Regan.

County Fair (page 55), 1989, 20 " × 32 ". Collection of Gerald Regan.

Yellowstone Church (page 59), 1970, 20 " × 40 ". Collection of Dr. Michael and Nancy Johnson Magnelia. The painting was commissioned in memory of Nancy's grandfather, John Johnson, who helped build the church in 1868.

Silo Filling (page 63), 1980, 16 " × 30 ". Collection of Gerald Regan.

Rural Free Delivery (page 67), 1968, 13 " × 23 ". Collection of Emil and Marcella Kammerude Klarer.

Farm Auction (page 71), 1988, 16 " × 28 ". Collection of Gerald Regan.

Country Store (page 75), 1988, 16 " × 28 ". Collection of Gerald Regan. The painting was based on an old photograph of a country store in Plato Center, Illinois.

Corn Shredding (page 79), 1980, 17 " × 30 ". Collection of Gerald Regan.

House Party (page 83), 1983, 14 " × 28 ". Permanent collection of Wisconsin Folk Museum. Purchased with funds from the Elmer G. Biddick Charitable Foundation.

Woodcutting Bee (page 87), 1988, 16 " × 28 ". Collection of Gerald Regan.

Winter Day (page 91), 1981, 16 " × 28 ". Collection of Gerald Regan.

Maple Sugaring (page 95), 1972, 15 " × 20 ". Private collection.

Sweet Clover School (page 99), 1989, 16 " × 28 ". Collection of Gerald Regan. This school was in vicinity of Mineral Point, Wisconsin; the painting is based on an old photograph.